To Regina

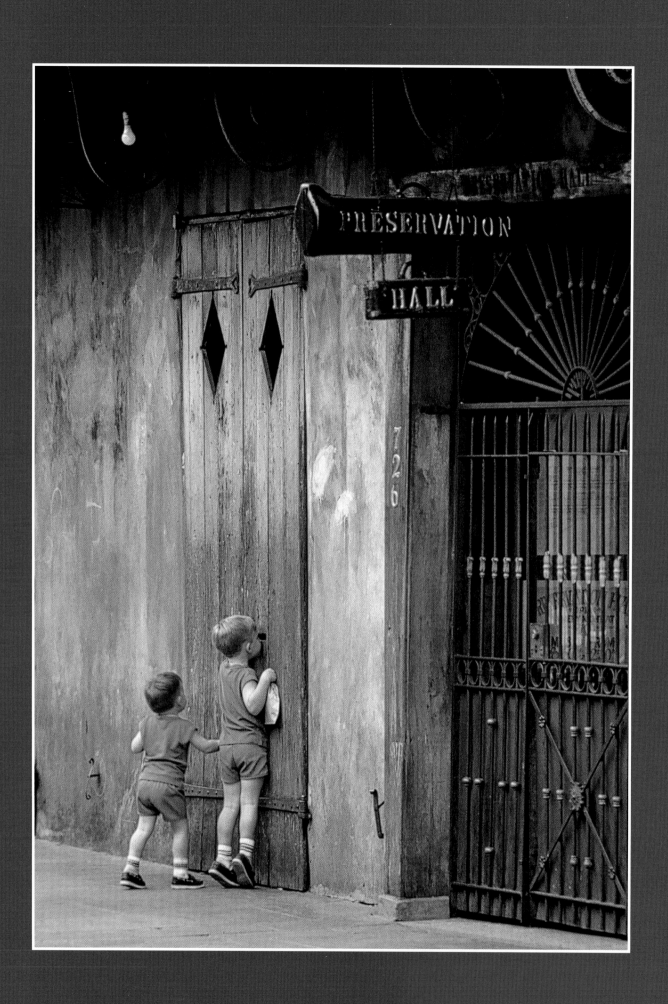

CONTENTS

INTRODUCTION

"Be the photographer that people hire because of the way you think, not just because you're a guy with a camera." ■ That's the best photographic advice I've ever received, and it's probably why I got to the top in a very competitive field. Success is not about the photographer with the best equipment, it's about the photographer who can think. Thinking photographers don't take pictures, they make images, and the work that I do—illustration photography—is the art of making images. ■ In this book I'll share many of the secrets and tricks I've learned about that art. I'm sure some people might wonder why I don't keep those secrets to myself so I can maintain my competitive edge. Well, the lights, cameras, film, and sets are merely bells and whistles. The thought process is my secret weapon, the brain my most important piece of photo equipment. ■ This book will take you through the thoughts that go into producing my commercial studio photographs. It will reveal what lies beneath the creation of my photos. It will also tell you what cameras I use, what lights, what film, which lens, and the like,

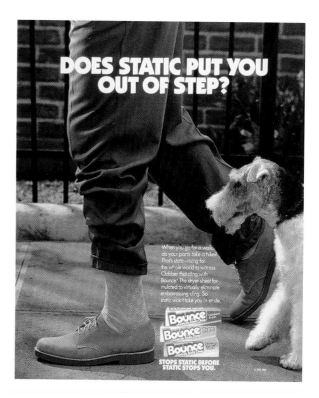

Layouts are like road maps for photographers—they tell you in what direction you need to go. Sometimes you're expected to follow every bend and turn, and sometimes you can take the scenic route, as long as you reach the client's destination.

but if you go out and buy the same equipment, place the lights in the same way, style the set like I do, and use similar models, you will have totally missed the point, and chances are you'll never compete at the upper levels of this industry. If things worked like that, you could buy the same brand of typewriter Hemingway used and write the next great American novel. There are many good photographers with great photo skills and good eyes. But the ones who can think get the plum assignments.

The type of commercial photography I do is also known as studio or illustration photography. It's called that because I'm asked to illustrate, with a photograph, a specific idea or mood for an advertisement. The difference between people or portrait photography and photo illustration is similar to the difference between documentary and feature filmmaking. The former records an observation, the latter creates one. I'm more interested in creating a perception than recording what actually happens.

Perception in advertising photography is all-important. To have that perception read quickly in a photograph, I need to create a visual shorthand. Everything needed to tell the story has to be right there on the surface for the viewer to grasp.

When I receive a client's layout for an ad, be it a rough thumbnail sketch or a complicated, detailed drawing, my job as a photo illustrator is to breathe life into that two-dimensional layout and

make it legible to the viewer. In the course of this book, I'll show you some layouts and the final photographs I created from them so you can see the concept as it was presented to me, and then see what I did with it.

In my lectures, I like to ask the question, "How many photographers does it take to change a light bulb?" My answer is, "Fifty. One to change it and 49 to stand around saying, 'I could do that!'" Yeah, we could all do it—but only one of us goes to the garage, moves everything to get to the ladder, schleps the ladder back to the house, scrounges around to find a new bulb (damn, none in the house, off to the store), sets up the ladder, and finally climbs up to change the bulb.

This book will tell you what makes a "good" ladder good and whether you should buy, rent, or lease one. It will also tell you what bulbs give the best light, where to place them, and whom to shine them on. Then it's up to you to do the work.

Often it looks easy, and for the most part a lot of it is easy. Actually doing it seems to be the hard part. I hope this book will inspire you to change some bulbs and shoot some photographs. Too many times photographers say, "If only I could get that new 800mm Super Deluxe lens, then I'd shoot some great photos." Which is like saying, "Right after I buy that new carbon fiber ladder, boy, are you gonna see some light bulbs changed!" What I'm saying is, don't wait for that perfect moment when the planets align. Take one simple idea from this book—like painting your own backdrop or lighting with a single strobe—and produce a photograph that's uniquely yours, one that reflects your point of view.

What makes my work different from anyone else's? I'd have to say it's my emotions. Anyone can learn the mechanics of photography. The cameras, lenses, film, lights, props, models—they're all ingredients, available to everyone. It's how you mix them that makes the difference. Just as two chefs can create different tasting soufflés from the same ingredients, and two conductors can create different effects from the same score, so can two photographers create different photos from the same equipment and the same layout. What clients want when they ask me to illustrate their ads is me—the emotional content and the personalized look I bring to my photos.

Taking pictures makes me look at things in a different context and from a different point of view. Once when I was in Paris it started to rain, and I grabbed my camera and ran out to catch the beauty of Parisian lights shimmering on wet pavement. If I hadn't been a photographer, I would have stayed indoors.

What makes a photo stand out is its "gesture"—the human element that adds a touch of soul to the image. Here, the great actress and model Abby Lewis added a tear for our photo of an elderly shut-in taken for a Meals on Wheels campaign.

When I was about 13 years old, one of my favorite activities was to pick a street corner in the downtown section of my hometown of Rochester, New York, and sit for several hours watching and photographing people as they passed by. I might have shot five frames or five rolls as I looked for a story that could be told by a single image. To this day, nothing intrigues me more than watching people. I love going to county fairs, pancake breakfasts at small-town firehouses, or just strolling along streets in New York City, not necessarily to take pictures, but just to watch. Taking pictures is the mechanical part of watching.

When I say "taking pictures," I don't mean "creating an illustration." My personal photos constitute a notebook of people-watching, and taking pictures for that notebook is a training process, like a boxer doing roadwork to build up stamina, because those pictures have an influence on my professional work.

This book will, I hope, explain to you and my mother what I do for a living. I define the thought process and the preparation that go into creating a photograph. The actual taking of the photograph is about 10 percent of what I do. It's the fun 10 percent, but I can't get to it without going through the preparation, the other 90 percent, first.

None of the work is a one-person operation. It takes a lot of people to produce the photo illustrations I create. There are, for example, location scouts, assistants, set builders, prop stylists, makeup artists, and messengers, and their work has to be coordinated. There is a lot of behind-the-scenes activity.

People-watching is as important to a photographer as roadwork is to a boxer. It keeps your visual muscles and reflexes in top shape.

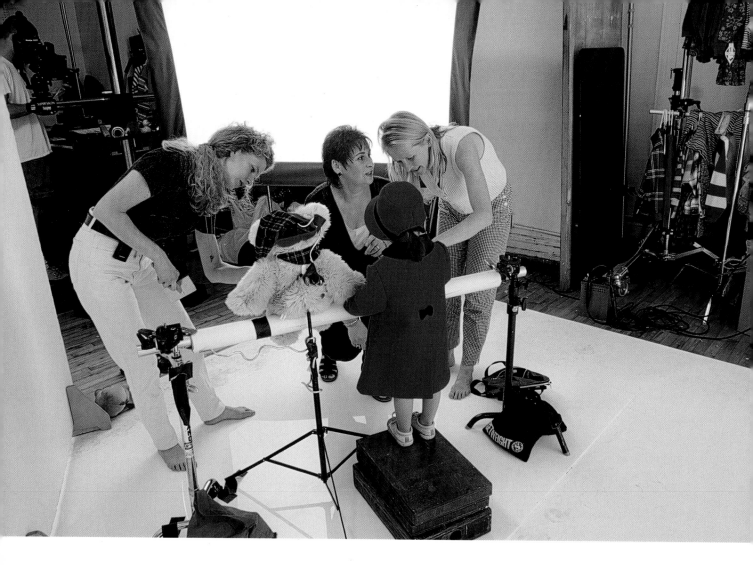

Photographing an ad is like playing a symphony. The piece can be played by a one-man band or an orchestra. Either way, the music is made, but with a crew— stylist, assistant, hair and makeup—the results are much sweeter.

Ancient Korean potters were known for using exceptionally fine glazes. The colors had an unmatched richness and depth. They achieved those colors by meticulously applying several undercoats of glaze that were not necessarily the same or similar to the color that was finally applied. By providing that rich base, a base that was never seen, they were able to achieve a beautiful final effect. In today's commercial photography, most of what is done lies beneath the surface. Most photographs are not taken, they're built, and without careful preparation you can't build a beautiful finished product. In a great photograph, it's the undercoat, the work done behind the scenes, that gives the picture its depth and richness.

My interest in photography started before I picked up a camera. It began with a fascination for light, shadow, and visual juxtaposition. When I finally picked up a camera at the age of 12, I was fascinated by the ability that photographs had not only to tell a story, but also to permanently fix those lights, shadows, and juxtapositions that I saw. It still fascinates me. Most of my stories involve people. I enjoy great scenics, but they do not hold me emotionally the way a photo of a person does. Sometimes it can be a simple portrait that tells me a story; sometimes it's a photo illustration.

I did the usual shooting for my high school paper and the year-book, then after four years of study at the Rochester Institute of Technology, I graduated cum laude with a BFA in photography. With that education, I thought I knew most things about photography. But after working a month as an assistant for a photographer in New York City, I realized how little I knew. College gave me a great foundation, but it was assisting that turned me into a photographer.

And I'm still learning. With the advent of digital photography, I find myself an eager student once more. That's one of the great things about photography—the education never ends.

I love environmental portraits for the stories they tell. This was shot in a roadside pub in Western Ireland. Though not the focus of the shot, the hand reaching in is intriguing. It establishes a sense that friends, while not seen, are gathered.

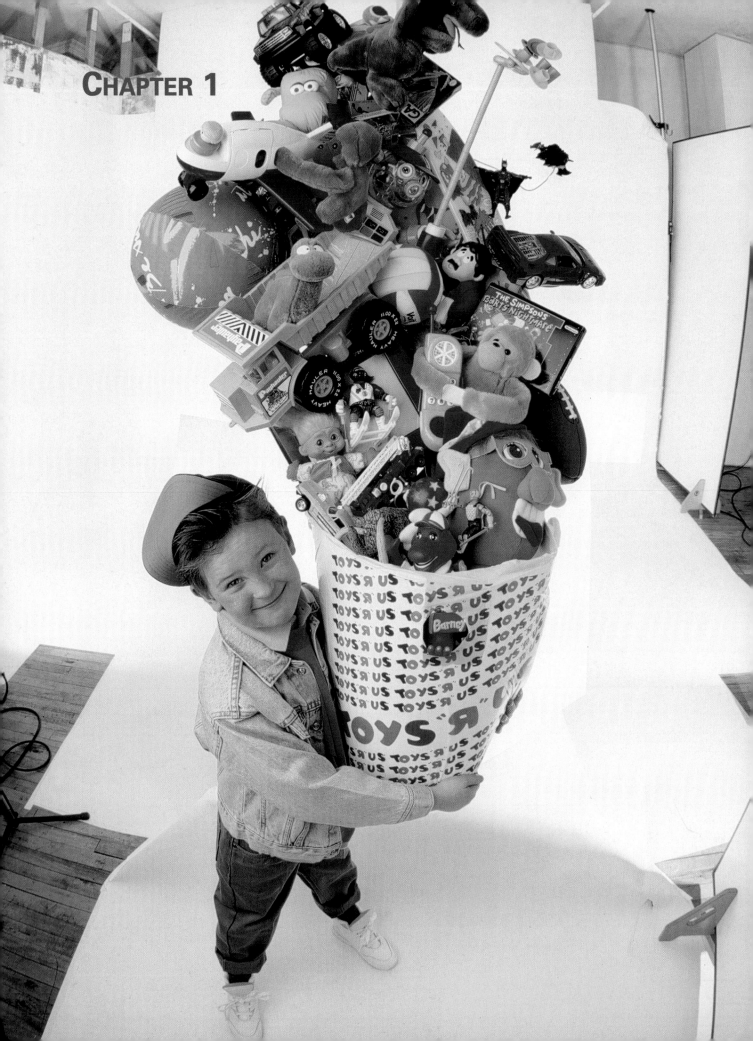

PRODUCTION

The Layout

Most jobs begin with a layout, an art director's road map to a photograph. There's an old Russian saying (told to me by an old Russian, in fact) that goes, "Seeing it once is worth a thousand explanations." So it goes with layouts. ■ The layout shows me what the art director is thinking. He (or she) could tell me to photograph an apple, and while I'm thinking "red Macintosh," he's thinking "green Granny Smith." ■ The layout clues me into the art director's perception. When he says "grandmother," is he seeing a Norman Rockwell granny with a cameo at her throat or a 55-year-old grandmother returning from her tennis lesson? Both are grandmothers, but visually they are worlds apart. ■ For that matter, I need to understand the client's perception as well. When a client tells me he wants a "young couple," I have to understand his definition of "young." For one of my clients, the demographic age of his customers is quite high, and while a "young couple" to most people means a couple in their 20s, for this client "young couple" means mid-30s.

Layouts come in many forms. Sometimes you'll get an intricate drawing, and other times (more and more frequently) art directors will submit "found" photos either in their entirety or cut and pasted together to get their idea across. This can be dangerous. Although following a general direction from a photo layout is OK, if you find yourself copying a pre-existing photo, you may be violating another photographer's copyright. This layout was a very original idea from art director Jim Ryan at Toys "R" Us.

A layout also lets me know how the art director sees the overall shot. Is it, for example, a three-quarter view or an overhead?

A layout tells me that I need to fill a vertical space (always with a horizontal subject, of course), or that I have copy considerations, such as making appropriate space for a title at the top of the shot or reverse copy in the lower left corner. (Reverse copy means that the words of the ad message will print white, making it my responsibility to make sure the photo is dark enough in that area for the type to be legible.)

Merely seeing the layout isn't enough, of course. I go over it with the art director. I once had a fourth-generation photocopy of a layout faxed to me, and I paid no attention to what looked like a thumbprint in one corner. It turned out that the thumbprint was actually a dog. "No problem," I said, "I can easily get a thumbpr..., er, a dog by tomorrow morning!"

One of the first things I find out is if the layout is etched in stone or just a rough concept. Sometimes I have to follow the layout exactly, no variations allowed.

I once was hired to do an ad for Crest toothpaste. When I first got the layout, I noticed that the dental chair depicted was a left-handed chair. So I asked if the direction the chair faced was important. I didn't know if the client was buying placement for this ad on right-hand pages only, which would make the orientation of the chair graphically vital. It turned out that the art director just drew it that way without knowing that left-handed or right-handed chairs existed. My asking saved me and my client time and money: a right-handed chair was easily available, a left-handed one would have had to have been ordered. The moral of the story: Don't just *see* the layout, *read* it.

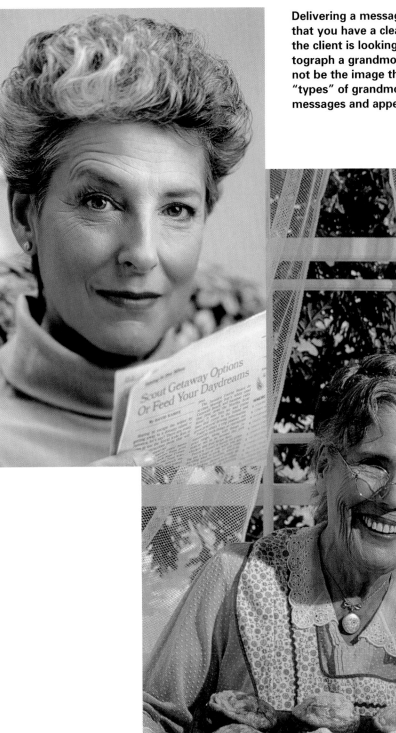

Delivering a message effectively in an ad requires that you have a clear understanding of exactly what the client is looking for. When you are hired to photograph a grandmother, your initial perception may not be the image the client has in mind. Different "types" of grandmothers send distinctly different messages and appeal to different demographics.

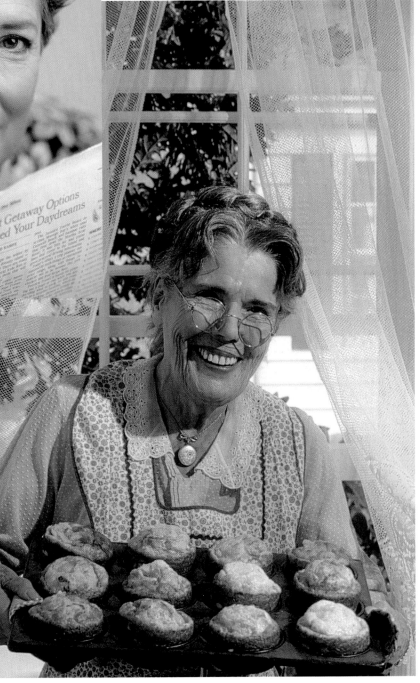

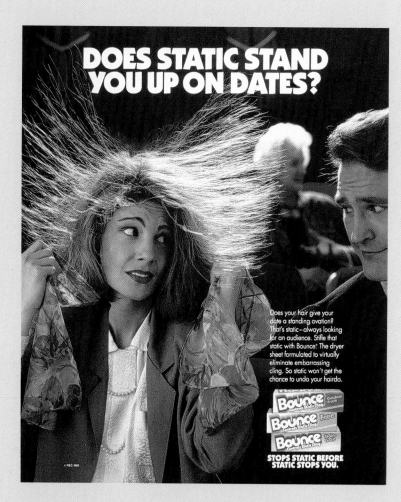

A Hair-Raising Event

This ad was shot almost exactly according to the layout. Even so, it brought its own set of challenges. Surprisingly, the hardest part was not getting the model's hair to rise, but figuring out whether to shoot the ad on location or on set.

Solving the hair issue was easy; it took one phone call. I quickly located a Van Der Graaf generator that we could rent. We had the model place her hands on the generator, plugged it in, and watched her hair rise as she became charged with static electricity.

What really worried me was the weather. If we were to shoot it on location, a humid day would prevent the model's hair from holding static. That would mean canceling an expensive theater location while we waited for a better day, which could get very expensive. So I tried it first in the studio with a set of rented theater seats, which we covered in rubber to keep the model from grounding herself. That didn't work; the model still grounded out. I then realized that shooting this ad in a theater would be impossible, so we built a theater set in the studio and had the model sit on a wooden box.

The shoot went well. The female model never felt a thing while being charged with all that electricity, but it was a different story with the male model. Every time he got too close to her, he got shocked with a loud "CRACK!" After about four or five times, he became wary of getting too close! (In the ad, you can see his hair being pulled to the "charged" model.)

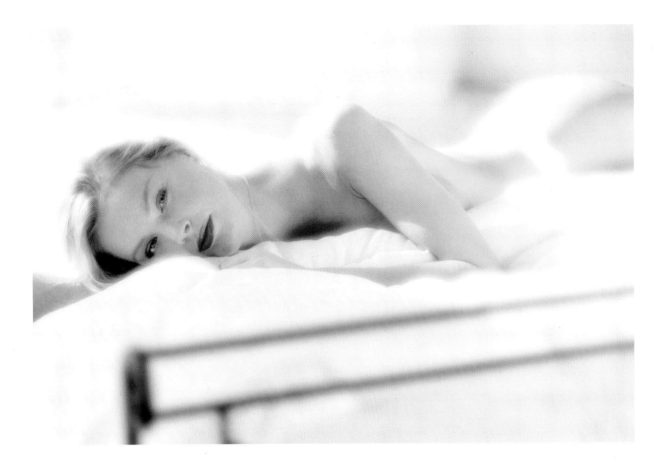

Finally, one of the things that marks a top pro is the ability to shoot within the constraints of a layout. Rather than seeing the layout as a problem, I see it as a script that I can interpret. Sure, the layout is an indication of what the art director is thinking, but it's up to me to make that layout my own statement, my own vision.

That's why if you give 20 photographers—20 *good* photographers—the same layout, you'll get 20 different images—all related by the layout, but all significantly distinctive.

The Studio

The studio is the place where the layout comes to life, and it should be a comfortable place to work. Its overall size depends on what you will be shooting most. I suggest planning a studio that will accommodate 90 percent of what you regularly shoot. If most of your work is with people, furniture, and breakfast cereal, and twice a year you have to photograph a Buick, it makes no sense to pay the overhead on a studio big enough for the car. When the Buick comes along, rent a studio for it. That's a much more cost-effective way to do business.

To photograph people, I need a studio long enough for me to take a full-length shot of three models with the camera and lens of my

Sometimes you just execute the client's idea and sometimes you get to shoot your own vision. This assignment to test the Mamiya 180mm f/4 Variable Soft-Focus lens gave me complete freedom.

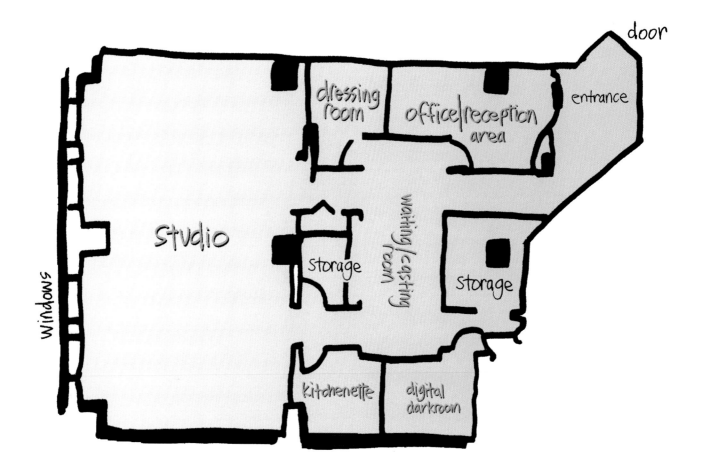

choice. That's about 25 feet (7.6 m). I need the space to be wide enough so I can place lights on either side of a seamless; that's about 15 feet (4.6 m). If I want to use a 12-foot (3.7 m) wide seamless or backdrop, then the required width increases to 18 feet (5.5 m). The ceiling should be high enough to place a light over a model's head, say 10 feet (3 m). I prefer, and have, a 12-foot ceiling.

It's important to get what you need, not necessarily what you want. The difference can save you a lot of money. (I'd love to have a studio that is big enough to shoot a 747...and even then, just a little bit bigger.) My studio shooting area is 38 x 20 feet (11.6 x 6.1 m). I also have about the same amount of space for my support areas: offices, darkroom, reception area. If you're shooting still-life tabletops, you might think you'll need less room, but most tabletop shooters I know always have a few setups sitting in their studios while the client approves the film. They may leave a setup intact for a week while they photograph one or two others. The space gets eaten up very quickly.

The one thing I thought I'd made adequate plans for (and am still short of) is storage space. Someone once asked me what he would need for his new studio—something that wasn't obvious, something easily overlooked—and I said, "Three things: storage space, more storage space, and then just a little more storage space." Truth is, it's a rule of thumb that no matter how big your studio is, you'll always want just a little more room.

Sets

I love shooting on a set. It gives me ultimate control: I can create a sunny day or a dark evening; I can be in this century, the last one, or the next; I can be in Norman Rockwell's dream or Alfred Hitchcock's nightmare. If the client wants an arched window, French doors, or wall sconces, it's no problem. We can build it...if we have the budget.

When building a set, I generally construct only as much as the camera will see, but I'll over-build the dimensions of a set if I know I might need to move around, if there are several different shots to be made, or

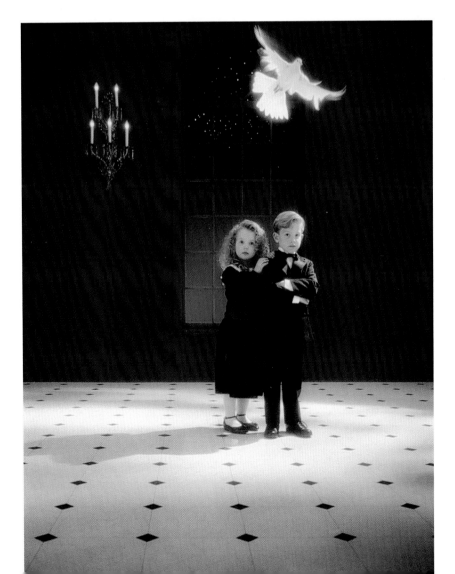

The art director wanted an arched window and a candelabrum in a specific location. By building a set in the studio, we could give him precisely what he wanted. Initially I wanted a painted floor so I could exaggerate the perspective, but he wanted a shiny floor, so a shiny floor it was. Real tile was too expensive for our budget, so we opted for white linoleum. We stuck down one-inch squares of black Mylar and then took a broad carpenter's pencil and drew lines where the tiles met. It created a very expensive look.

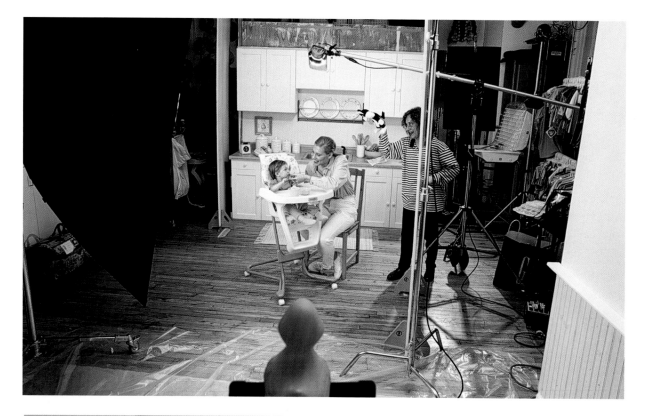

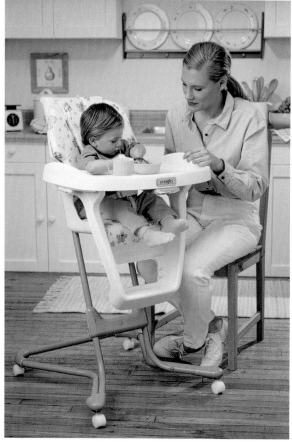

There are some sets, like kitchens, that come up over and over again. I have a "stock" kitchen set in storage. It's all false fronts and can be put together very quickly. I can also easily change its look with paint, wallpaper, props, a different Formica countertop, and even a sink.

if I'm working with an art director who changes his mind a lot. But for the most part, if I need five feet of house, I'll build six to eight. I also build a set for appearance, not for taking out a mortgage. There are many tricks to building a set that make it real to the camera even though it's just a shell. In photography, we're very shallow; we care only about appearances. You don't have to be in a real ballroom or a real bedroom, as long as it *looks* real.

A set builder understands what it means to build for the camera's eye. Just because someone can single-handedly build an entire inhabitable house doesn't mean he can build a set. A set requires a different sensibility, someone who is detail-oriented—but not to the point of spending too much time and money on details that won't be seen. A good set builder knows when to get good birch wood for a molding and when to get common pine; sometimes it makes a tremendous difference in the final result, and sometimes it's "just eyewash," as one of my set builders likes to say.

Paint it, prop it, populate it, shoot it. It's that easy.

WHY NOT SHOOT ON LOCATION?

People who see a shot and realize it's a set often ask, "Why didn't you go on location and shoot it for real?" I'm glad you asked. There are several reasons. First, most of the time I'm shooting during the wrong season. Because of the way deadlines work, I'm usually shooting six months ahead of the season I need to depict. Christmas comes in July, and I'm shooting summer in the dead of winter. It's hard to do a beach scene around New York in February.

Then there's the issue of control. In the studio I know I'm not a slave to the weather, and I don't have to worry about a storm ruining the shoot. In the studio I'm in a better position, literally, to match the layout. That isn't a big consideration

for some shots, as the elements are fairly basic, but there are some layouts in which the placement of the architectural elements is crucial to the ad copy. And, given the limitations of time and budget, it's sometimes impossible to find exactly what the client wants in the real world. By building in the studio, I have a much better shot at giving clients what they want. Also, in the studio I can control the lighting, and I'm confident I can light a set so it doesn't look like a set.

Usually the main reason to shoot on a set is cost. To shoot on location, you have to hire location scouts, pay for their time, travel, and film costs, send what they find to the client, and hope that you get the right location on the first pass. If not, you have to send a scout out again. Of course, there are some location services that have files of locations, but still there's usually a search fee involved. And after you've found the perfect location, there's the location fee, which can range anywhere from $1,000 to $2,500 per day for a print shoot. You also have to get all your equipment packed and transported to the location, along with your support staff and assistants (usually a second and sometimes a third assistant just to help with the packing-unpacking, packing-unpacking routine). In New York I also have to pay the models' travel time if we shoot outside the city, like in New Jersey, which is just a half-hour away. This all adds to the bill.

For many advertising clients, none of this poses a problem. They have the budget, and in order to get the right look for an ad, they'll spend the money. But a lot of times these photos are not done for national ad campaigns—they're done for a trade ad or a brochure for which the budgets are quite tight.

While it's often cheaper to shoot in the studio, it's not always. If someone wants a supermarket shot, I know I can rent all the fixtures I need to build a supermarket in my studio, but it's stocking the shelves with merchandise that

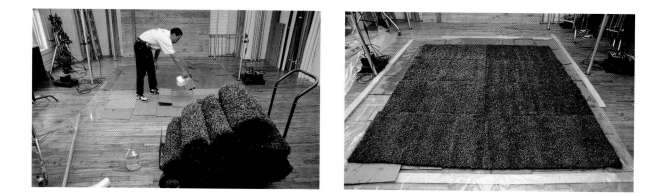

This gardening shot was part of a 12-page calendar I did for a pharmaceutical company. It would have been very easy if we could have shot it on location, but because we had to shoot it in November, we had to create a garden in the studio. If it had been just a little earlier in the season, we could have gotten the sod locally, but when we called, the local sod farms had just stopped cutting because of a dip in the weather. Frozen sod just can't be cut. So I had to fly sod in from Southern California. I could have resodded my front and back yard for what this 10 x 10-foot patch cost! The cost of the sod itself wasn't too bad, but the overnight air freight bill was a real eye-opener.

To lay the sod, we first covered the floor of the studio with plastic. We then laid cardboard on the plastic and watered it to keep the sod from drying out. The edges of the plastic were then raised with strips of wood to keep the water from running onto the studio floor. We also brought in a few hundred pounds of topsoil to make a garden bed.

Prop it, light it, and there you have it—summer in winter in NYC.

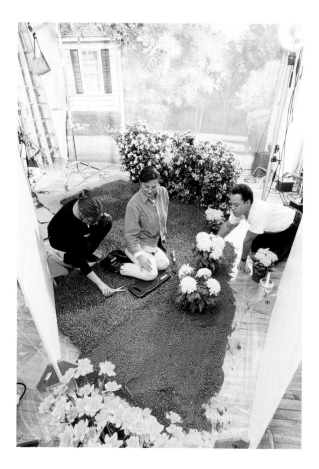

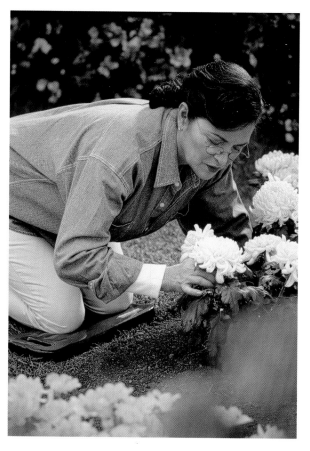

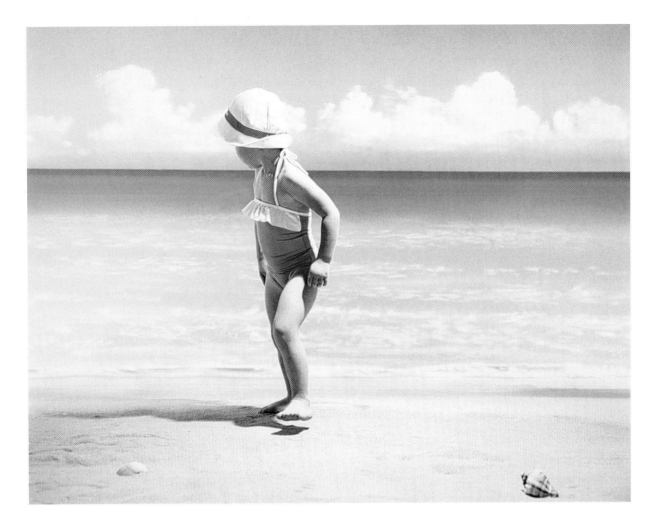

becomes a problem. Unless I'm shooting just the client's product, it's easier and it looks more realistic to shoot on location. And certain places just don't look right when they are recreated in a studio. A supermarket is one of those.

For the most part so is a beach, although I've shot some incredibly realistic beach scenes in the studio—like this little girl running. What you see in this shot is about 300 pounds of real sand and a painted backdrop. It was originally done for a brand of children's suntan lotion. What happened here was not a result of careful planning, but rather of my being prepared to get lucky. The young model, being all of about two years old and not understanding the subtleties of modeling, just wanted to have fun. She realized that it was great fun to run up to the backdrop "water" and kick it to make the whole scene move. She did just that, and before we put her back on her mark in the foreground, I snapped the shutter mainly to finish a roll so I could start with a fresh, full roll of film when she hit her mark. The result of that quick, throw-away shot was this, an image I love.

When I saw this frame of this little girl in front of our studio beach, I just fell in love with it. It is full of what I call "gesture" and has a great "caught moment" feel. You hope to get a picture like this at every shoot, but all you can really do is gather the elements, throw them together, and hope that your reflexes are good and that there's film in the camera when the perfect moment occurs.

25

Decisions, Decisions

I once had an assignment to shoot an ad for AT&T. The underlying concept was to convince businesses that by utilizing AT&T's services, they could stay in touch with their customers' tastes, trends, and preferences. Without AT&T's services, they'd be left in the dark, shelves would soon become overstocked with out-of-style merchandise, and business would suffer. Hence with AT&T's help, merchandise would fly off the shelves! Luckily, I rarely have to explain the concept, I just have to shoot it.

This AT&T ad was quite simple from a photographic point of view, but it was extremely complicated at the production end. After seeing the layout, my first question was, how big should I make the shelves? Well, that was pretty easy: Get a sweater, fold it, stack it, and figure out the average size of each square in the cabinet. Then determine how tall the average model is. (I hadn't cast the model yet, and would not have enough time to build if I waited until I did.) I decided that the height of an average model was 5'9", and then I figured how high she'd have to reach.

OK, now, how many compartments? How many high and how many wide? I came up with the numbers, stretching the width a bit to make sure it fit proportionally into a double-page ad—and ended up with dimensions for a unit that would be too big for me to shoot in my studio. I'd need a sound stage to shoot a unit that big, which would be overdoing it a bit for this shot. So I decided to build one manageably sized unit and photograph it twice. For the perspective to make sense, I lined my camera up with the left edge of the unit when I shot the right side of the ad, and with the right edge when I shot the left. Then I put the two photos together.

I decided to shoot this ad on 4 x 5 film rather than 120 because the detail and sharpness of the sweaters would be better reproduced by the larger format. Besides, there would be very little in the way of "capturing a moment" here.

The sweaters needed to be stuffed and fluffed to make them look fuller, reducing the number of sweaters I would need for the shot. The stylist brought in an assistant to help with the folding and stuffing. I allowed a day for the folding and stuffing of the "not hot" sweaters, which took more prep time than the "hot" ones simply because there were more of them. (The idea was that "hot" sweaters sell, "not hot" sweaters stay on the shelf. Details like that can mess you up if you don't think the job through.)

The art director also wanted to "ground" the shot with reflections, so I put a piece of Plexiglas on the floor. When the shots were assembled, the art director decided the reflections were too distracting because they ran into the copy space, and she eliminated all but the one under the model.

All in all, a lot of thought and planning went into what was basically a straightforward shot. And because I bought so many ugly sweaters, I figure we must have skewed sweater sales figures to the point where a clothing buyer might have said, "Gee, ugly is selling pretty well. Better stock up."

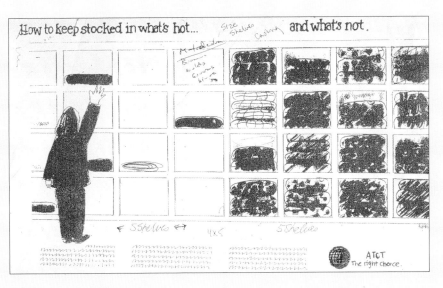

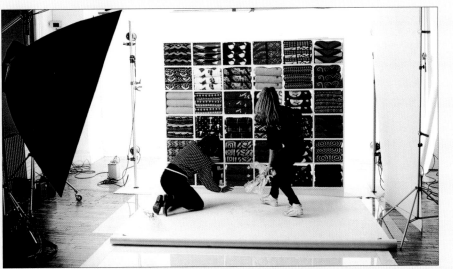

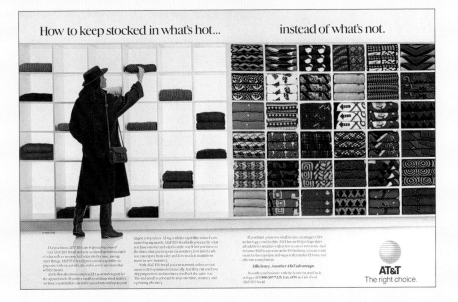

BUILDING A SET

The first step in building a set is to turn the art director's rough sketch into real dimensions. I don't want to find out while I'm shooting with models on the set that the art director needs four more feet of width than I built.

I always look at the proportions of the layout. If it's a long vertical, and I can tell from the layout that there's double the model's height above the model's head, and I assume we'll have a 6-foot-tall model, I know I need an 18-foot-tall set. That's hard to do in my 12-foot-high studio. But if it's a 3-foot-tall child with that same proportion above her head, I know I can build it in my studio.

Say the art director wants a product to fit under a window. Is that product short or tall, and will it look proportionally odd on a set? Will putting a 5-foot product under a window make the window way out of proportion on the set? Or will a 1-foot product placed under a standard height window cause the window to be cropped out in the final shot? These are questions you have to resolve before you build a set. On some children's sets, I tend to shorten everything (such as windows and chair rails) so they're closer to the ground than normal. Then the trick is to keep the set looking natural and not stunted.

The budget is the next thing to consider. You don't want to commit to building the Taj Mahal on a tool shed budget. You have to be able to realistically estimate the cost of a set. That takes experience and common sense. It's a question of knowing when the shortcuts will work and when you need to do things the long way.

Shortcuts? There are lots of them—like fake kitchen cabinets instead of real ones. I once had a set builder create kitchen cabinets with just a roll of 1/8-inch black tape (to suggest doors and panels) and a couple of knobs.

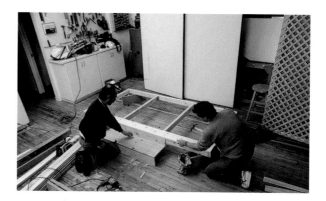

Building the front of a house can seem daunting, but it's not too bad if you construct only those elements necessary for the set to read as a house. In this first photo the house porch is shown as the base was built.

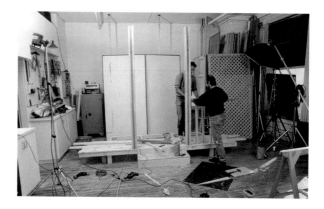

Then the two columns were put up. They are 4 x 4-inch pieces of wood with corner molding to make them look like finished porch posts.

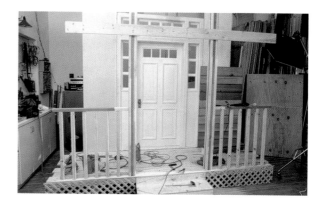

The doorway is a "stock" piece that was rented from a prop rental company.

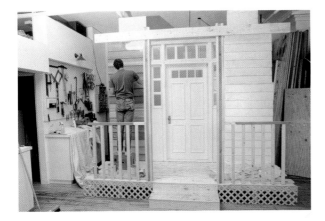

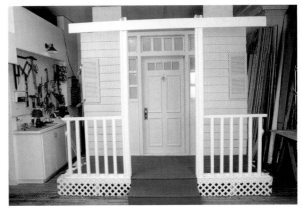

The siding is real wood siding, bought at a lumber yard, and nailed onto a set flat. The floor of the porch is just standard 1 x 4 pine painted brown. A 4 x 8 piece of lattice was cut down to give the front of the porch some more visual texture.

The devil is definitely in the details in a set like this. The set builder, on this set Charles Schindler, and I constantly go over the placement and proportion of everything going up. There have been many sets where I told Charles to build something like the width of the porch posts at 3 feet and then had him redo it at 2-1/2 feet or 3-1/2 feet as it was being built. A lot of set building is done by Braille as we go along. You can't be intimidated about redoing something if you think it will lead to problems later. The only thing that counts is what you get on film.

For the little we saw through the camera, no one could tell they were fake. But other times, because of the layout and how important the cabinets were in the shot, fakes just wouldn't do. How do I know when faking it won't make the grade? Experience.

The next step in building the set is a sketch, which can come from the art director, set designer (on a really big-budget job), set builder, or me. It can be a rough overhead view of the set, detailing the proportions and where various elements will go, or an involved, three-dimensional perspective drawing.

At this point I physically lay out where the walls will go, using 4 x 8-foot (1.2 x 2.4 m) sheets of foamcore as stand-ins for real walls. Sometimes I lay the set out with tape on the floor, so I know where the elements and the walls go. This step has saved me from building too small or too large a set. Think of it as visual doodling. I can visualize where I will place a 2-1/2-foot-wide couch if I have two people four feet away from a wall; I can see that a certain height wall is not tall or wide enough if I'm going to use a 110mm lens on my Mamiya RZ67. Making the wall 10 or 12 feet (3 or 3.7 m) tall or changing to a 180mm lens solves the problem. It's much easier to work it all out with foamcore and stand-ins than waiting until you're on set with costly models. "Oops" is a word you want to avoid saying on set. The foamcore and tape method also tells me how much material I need to order. With budgets tight and storage space in my studio even tighter, I don't want to over-order lumber and set material.

Finally, I build the set.

I've found it very helpful to have my camera set up and in place, mounted with the lens I plan to use for the shoot, while the building is going on. That way I make sure everything is built to my perspective. (I place a garbage bag over the camera to protect it while the actual building is taking place.)

A good tip for making the outsides of houses (or the small sections that the camera will see) look real is to use clapboard. It's easy to get, and most important, it reads quickly as a house. Most lumberyards have plenty in stock.

...Which brings up an important point to consider about materials, including props: Never assume that because you see something "all the time" or "all over the place" that you're going to find it when you need it. Reznicki's Law states, "Things tend to disappear in proportion to your need for them." Always check that what you want is in stock. I once needed a set built in two days, and one of the key things I required were bright yellow tiles. Everyone sold the tiles—but none were in stock, and I didn't have a week to wait for

The best laid plans of men and set builders....We needed bright yellow tiles for a Brawny paper towel project, but because of our fast-approaching deadline we couldn't get any in yellow. So we bought white ones and painted them. Though a small part of the project, painting the tiles took a lot of time. Not unusual.

an order. I ended up having to paint white tiles yellow. (On my first attempt, the evening before the shoot, the yellow paint came off when I added the grout, so I had to spray paint the tiles at the last minute.)

I always try to have alternative sources. For instance, another way to go with clapboard is to use vinyl rather than real wood. You can pick up vinyl clapboard from display providers. They have vinyl siding, about 30 mil thick, that's used in store displays, and it works very well in photographs. Vinyl clapboard can also be found at home improvement superstores.

SET BUILDERS

I build simple two-wall sets with my assistant. But if I need a complex set or one that has to go up quickly, I call a set builder. Set builders can custom build doors and windows to the client's or my specs; they can build dormer walls, reverse corners, all sorts of things. Many times, I have to go over the layout with the set builder to determine, among other things, dimensions and sizes, and placement of windows and moldings. Set builders understand moldings and wood types. They know if a colonial molding will work or if we should get a plain, clear 1 x 3-inch piece of wood. They know if we should build the window flush to the wall, box it, or put a decorative molding around it.

I've found that hiring a good general builder or someone who's handy with tools is not the same as hiring a set builder. Set builders think differently; they understand a photographer's problems and

requests. They build to the camera, which saves time and money. Many times an art director will give me a layout that looks OK to me, and then when I show it to my set builder, he will point out that we can't build it that way, or if we do, there will be problems I had not anticipated.

FLATS

Flats, the heart of any set, form the skeleton that the set is built on. The standard size is 4 x 8 feet (1.2 x 2.4 m), with variations such as 2 x 4 (0.6 x 1.2 m), 4 x 10 (1.2 x 3 m), and 2 x 10 feet (0.6 x 3 m). To make bigger walls, just join several flats. To tie flats together, I lay them face down and fasten the sides together using only as many sheet rock screws as are needed to secure them. (Whatever is put together has to be taken apart, and using too many screws will not only be a pain when you take the set apart, they may damage the flats. I have some flats that are over ten years old and are used every month. Constructing flats well and maintaining them pays off over time.)

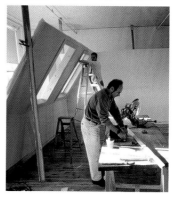

For a diaper ad we needed a set with a slanted dormer and built-in windows. The windows didn't really show in most of the shots, but that's not unusual with a lot of sets. It's the atmosphere you're going for. The light against the back wall was created by a strobe pointed through the window.

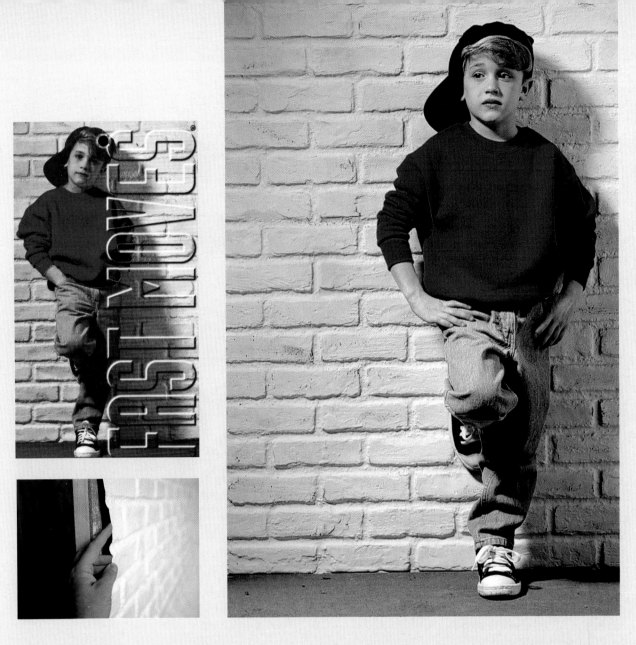

Instant Brick

I was asked to shoot a hang tag for a line of Kids "R" Us clothing. I wanted the background to be as clean and simple as possible and thought a white brick wall would be ideal. I knew we couldn't build a real brick wall quickly enough, and the rental studios that have exposed brick walls don't take kindly to people whitewashing the walls they laboriously sandblasted and returned to their natural color. Fake brick from hardware or building supply houses looks too much like fake brick; the individual bricks always look too perfect.

However there is some fake brick that works really well, and I've used it many times. I get it from a display company, Provost Display, that makes plastic backgrounds. What makes these so great is that the mold used to make the background is made from an actual old brick wall. All the imperfections have been left in; a couple of nicks and dings were even added. The backgrounds are plastic sheets, 30 mil thick. They can be rolled up and shipped and come in 4 x 10-foot (1.2 x 3 m) horizontal strips.

Once we put the wall up, I used some putty on individual bricks to give it a little more character before I painted it. I placed it on top of a fake sidewalk made of sand-painted board. I think it reads really well. The great thing is that I can save and reuse the bricks for three or four more jobs.

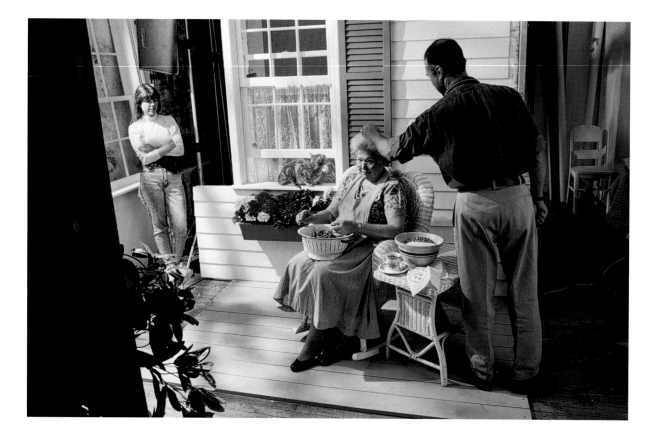

To shutter or not to shutter. I knew this would be a fairly tight shot and that only one shutter would show in the final composition, so we built the set with just a little more area than was needed. I was working for a long-time client. Had it been a new client, we would have used a second shutter. That's what we call "eye-wash"—something that makes no difference to the final shot, but is there for the client's benefit.

One of the reasons to build flats in standard sizes is that the material to cover the flats—generally luan (a 1/4-inch-thick piece of plywood, finished on one side) and sheet rock—come in standard sizes, and it's always easier to work that way. If everything comes in 4-foot (1.2 m) widths and all the flats are 38 inches (0.97 m) wide, it becomes a real pain and wastes a lot of time getting everything to fit a non-standard dimension.

You can put several flats together to make 8 x 8 or 8 x 12-foot (2.4 x 2.4 m or 2.4 x 3.7 m) walls. Connect two walls, and you've made a corner. Add a window or door, and you're on your way to building the world—or a reasonable facsimile of it. When windows are used, you'll need a small flat, called a plug, to build the wall above and below the window.

Keep in mind that if you do add a window, you'll need a window treatment—curtains, shades, blinds—and in many cases something behind the window. That means that you need enough room behind the window (and the set) to place the background, seamless, or props, and you also need room for lights to illuminate the background. (No one said that building the world was easy!)

For transport and storage, flats should be as light and thin as possible. I've seen photographers build flats with 2 x 4s so that it takes

four struggling people to move an 8 x 8-foot (2.4 x 2.4 m) wall. Build flats with 1 x 1 or 5/4 x 5/4-inch clear wood (that means wood with no knots; knots create weaknesses in the wood). The reason to build the frames with such narrow pieces is that they'll have a smaller profile and take up much less storage room than thicker flats. Not to mention the weight. Two people can easily move a 12-foot (3.7 m) long wall built with a smaller frame.

After I build a frame, I cover it with luan, fastening it to the frame with glue and nails. I never paint or wallpaper this luan surface, but instead, cover it with another piece of luan or with sheet rock, muslin, or something else, and use that surface as a base for decorating. This insures that the original luan is not destroyed too quickly and allows the flats to last for many years. If you work with the original luan surface, the flats become unusable in a very short time.

When putting up flats to make a wall, use a good level to make sure the walls are straight and true. To hold up the walls, I use floor-to-ceiling, center-adjusting AutoPoles (by Bogen) or Timber Toppers (metal boxes with a spring inside that fit on the end of a 2 x 4), which can be run from floor to ceiling. AutoPoles and A-clamps are good for steadying sets that are lightweight or temporary, but for shoring up heavy walls or walls that have to be more sturdy, I prefer the Timber Toppers. Because they are mostly wood, the Timber Toppers can be screwed into the flats, and then both the Timber Toppers and the bottom of the flats can be screwed into the floor, making a very sturdy set.

If you don't have the luxury of being able to screw or nail into a wood floor, you can use wooden jacks—diagonal pieces of wood screwed or clamped to the set wall and then sandbagged at the bottom—to hold up the walls.

WALLS

One of the easiest ways to build a long stretch of seamless wall is with muslin, a lightweight, inexpensive canvas-like material that's often painted and used as a backdrop.

To build a wall, let's say 12 feet (3.7 m) long by 8 feet (2.4 m) high, you can screw three 4 x 8 flats together. If you were to paint the flats, you'd have to hide the two vertical seams in the wall. Instead, you can stretch a piece of muslin (just as you would stretch a piece of canvas) on a frame and then prime and paint it. The muslin does not have to be tight. In fact, I don't like it too tight because it shrinks when it's primed. By covering the flat with painted muslin, you have a seamless wall.

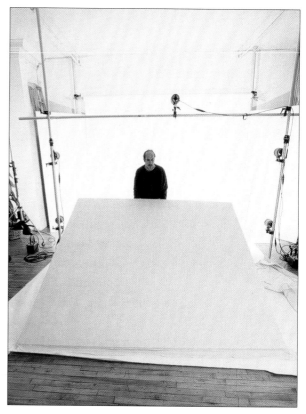

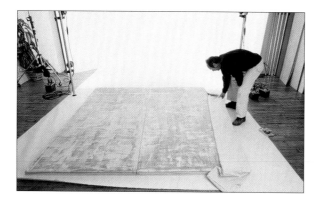

Making a set wall out of muslin is just like stretching a canvas on a frame. However in this case, it happens to be a big frame. First, make a wall the size you need and cut a piece of muslin large enough to wrap around the sides of the frame. If the wall is larger than one flat, you'll have to attach several flats together from the back. Flip the wall over, laying it on top of the piece of muslin. Staple one side of the cloth to an edge of the flat with a staple gun, then stretch and staple it to the wall's opposite side. Next stretch and staple the third side, and finally, the last side. The muslin doesn't have to be stretched extremely tightly, because it shrinks when painted, which takes out all the wrinkles. This is the perfect way to cover a large wall because there are no seams where the flats are joined together.

I usually use a light-colored latex paint to prime the muslin, or even a coat of the final color that I'll be using for the set. Use a lighter color for the prime coat than you'll use for the finish coat because a darker undercoat will show through the final coat—beige does not cover forest green well. Most likely, I'd use white or beige paint to prime the muslin.

Why not use primer? For these purposes, I've found no advantage to it. The only exception is if I'm going to wallpaper the walls; then I'd consider using a true primer because wallpaper needs a good barrier between the glue and the raw muslin. Muslin is extremely absorbent, which can be a problem when applying wallpaper.

Wallpapering muslin can be tricky. I find it's best to apply additional paste to pre-pasted wallpaper, as pre-pasted wallpaper alone doesn't stick well to muslin. I'm also very careful to make sure the edges of the wallpaper are well glued, as they are the first to separate from the wall and cause the most problems during a shoot. Basically, if I'm going to use wallpaper, I avoid using muslin altogether and use a luan or sheet-rock wall instead. Why look for trouble?

Muslin comes in many widths, and you can buy as much as you need. With muslin I can build a 10 x 30-foot (3 x 9 m) wall quickly and inexpensively. I can get muslin as wide as 16 feet (4.9 m), although most of the time I use 8 to 12-foot (2.4 to 3.7 m) widths. You can get muslin at a good art supply house or at a theatrical fabric store. Another advantage to muslin is that when you're done shooting, it's very easy to tear down and throw out a wall. Disposing of a wall made of sheet rock or luan takes a lot of time and a large trash container.

Sheet-rocking flats creates the most perfect walls, excellent for both paint and wallpaper. But it is the most time-consuming method of building a set, involving two or three coats of spackle, time for each coat to dry, and then you have the real mess of sanding the seams. If you have to spackle, you can smooth the seams with a moist sponge so as not to raise dust, but it's still a mess.

BACKDROPS

One thing I enjoy doing myself is painting backdrops. Not specific things like clouds or scenics, but abstracts, which are very useful in a variety of shots. Since I don't know what I'm doing, I end up with some very nice-looking drops. The secret is that I can always paint over any of my mistakes.

The techniques are relatively simple. First, muslin is the most inexpensive way to go: an 8 x 10-foot (2.4 x 3 m) piece is within anyone's budget. Next, if the budget won't stand good scenic paint (which is very good), you can always use odd latex paints you might have around the house or mismatched latex paints that paint stores always have on sale. I start by painting a base color on the muslin. I water down the paint—it makes adding colors easier and makes the paints blend better. Most of the time I leave the paint very wet and watery, but sometimes I wait until it dries a bit and then add other colors. When the muslin is still wet, colors blend well. If the muslin is dry, the additional colors add a distinct edge and contrast to the original coat.

You can use a variety of techniques to add paint to the canvas. Flicking, rolling, painting, anything works—the idea is to experiment and have fun. Use a paintbrush to flick paint on the muslin. Use a color similar to the base, or lighten the base color with some white. Or you can flick a completely different color on the background. Sometimes I water the added colors down a lot, sometimes I use them full strength, and sometimes I use a roller to apply

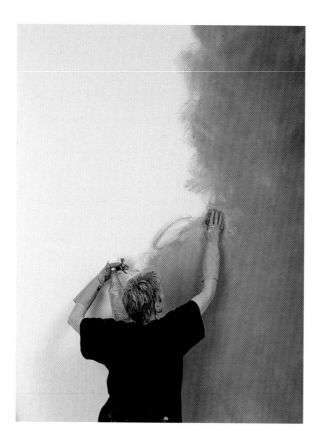

A professional scenic painter can add so much to finishing the look of a photo. It's easy to think, "Oh, we'll just paint it," but that can be a big mistake. Sure, anyone can do it, but it always looks better when done by a professional. The scenic painter who painted this backdrop, Louise Hunnicutt, is an accomplished artist in her own right. Painting backdrops is like breathing for her and it is just a small portion of her talent. This backdrop was commissioned by me for a "stock" backdrop for my studio.

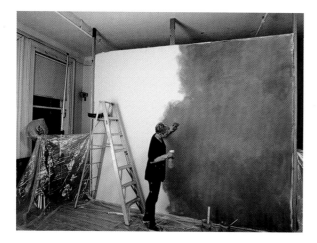

them. You can even roll a paint-soaked rag on the muslin. Hmm...that dirt looks interesting, I wonder what that'll do? Once I've started, I find the hardest part is to stop. It's easy to overwork a piece.

Once I've painted the backdrop, I photograph it. I have one backdrop that looked terrible when I held it in position—I thought for sure this was one I'd be painting over. But I did a quick test on it and was quite surprised at how good it looked in the photographs. You never know. And it's amazing how many different looks and how much mileage I can get from a backdrop by adding light or shadow or gelling the lights.

Now, if you're all thumbs and scared to death to take a paintbrush in hand, there are many places you can buy or rent ready-made backdrops. Just make sure it's a good-looking backdrop. I've seen some pretty horrible ones, especially those that are commonly sold to the portrait and wedding market. Look at a lot of photos and check a lot of resources to see what's elegant, what's hokey, and what's just plain ugly. There are also many good backdrop rental sources that have beautiful backdrops for photographs, and they ship all over the country. Rentals can cost more than buying one at a backdrop factory, but their look and quality make it worth it. I got one of my favorite backdrops by trading a portrait session with the backdrop painter for a custom painted backdrop.

I've also done well going to fabric stores and buying very good fabric, such as sofa upholstery, and using it as a backdrop. It's expensive—$25 to $50 per yard—but it's a fantastic bargain for the quality of the background you get.

Remember, you don't need to get anything expensive, just be imaginative. I used a tablecloth for the background of the photo of the twin cherubs.

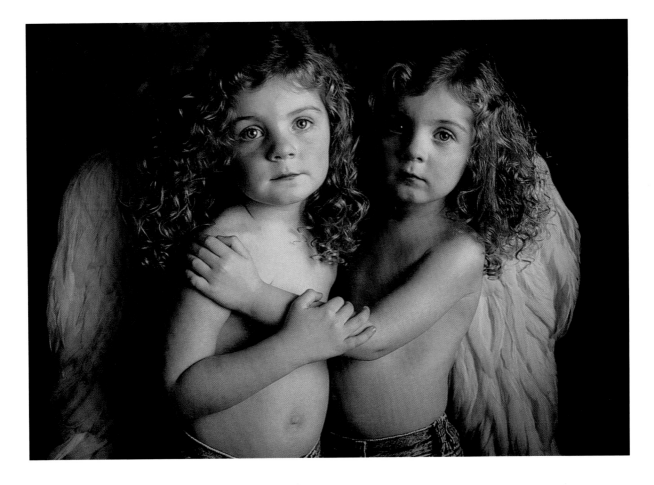

I like using fabrics for backgrounds. I have picked up several very nice, fairly expensive tapestry materials at the fabric store. Although $30 a yard adds up to a lot to cover a couch, three yards is quite affordable for making a background. I found this tablecloth at a home furnishings store, and it cost even less.

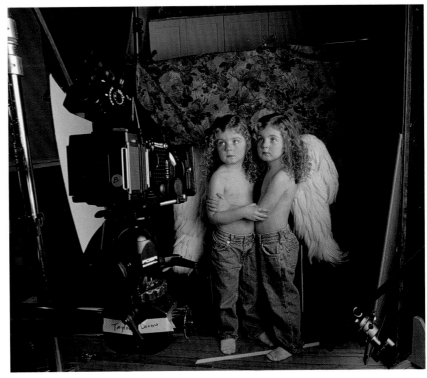

MOLDING

Once the walls are up and painted or wallpapered, you can then add the little touches that finish off a set. Moldings add an ambiance and visual texture to a scene. It's amazing what adding molding to a wall, door, or door frame can do to improve the look of a set, not to mention the number of flaws molding can hide. After all, that's why moldings were first invented—to hide building flaws.

You can also use ceiling molding to fake a ceiling. While I have made sets with ceilings, it's very hard and very time-consuming. I find it easier to just put a molding up near the top of my set and let the set above it be a solid color, often white. If more is needed in the layout than I can build in the studio, it's very easy for the art director to just add more color, right above the straight edge of the ceiling molding. This fools the eye into thinking that there really is a ceiling up there.

Floor molding hides any irregularities where the wall meets the floor. Chair rail and other decorative moldings help give the set a finished look. It pays to go to a good lumberyard and talk moldings. That way you know what your options are—do you want a plain, clamshell, or detailed colonial molding for a particular set? Most lumberyards that carry a good selection of moldings have molding books that picture cut-away profiles and the dimensions, which makes ordering moldings a lot easier.

Not only is molding useful in adding dimension and visual interest to a set, but it also can hide a multitude of problems. Sometimes the walls don't meet the floor evenly or window casings don't butt up against the wall perfectly. That's why molding was invented. Also, painting the molding a contrasting color gives the room a paneled look, adding texture and depth to the scene.

SUPPORT CREW

A good illustration photographer is more a symphony conductor than a one-man band. Sure, I can load my own camera backs, keep the film notes, adjust the wardrobe, and play peek-a-boo with the baby who's my subject for the day, but my concentration and timing suffer, and as a result, so does the photo. In order to produce a great photograph, I need to conduct a group of people; without them, I'm just a guy with a camera.

■ The staff I use, whether full-timers or freelancers, is comprised of high-energy, creative people like stylist Sally Nachamkin and hair and makeup artist Gui Vrabl, shown at left. I don't want to surround myself with non-thinking drones. The people I work with bring their individual points of view to the job, and they help improve whatever we're working on. An assistant or a stylist might suggest an idea that not only benefits the photograph, but also enables me to see things I may have neglected; perhaps it expands my awareness of other possibilities. I often get so wrapped up in what I'm shooting that any suggestion, good or bad, makes me stop and look at what I'm doing from a different perspective.

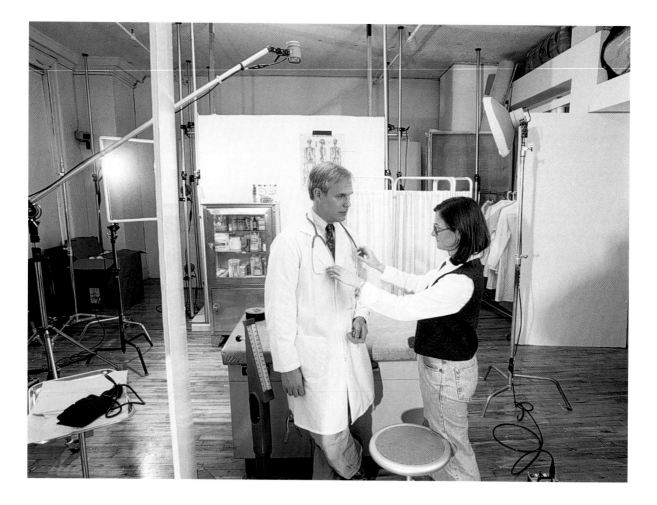

A stylist is one of the greatest inventions since sliced bread. Stylists are always busy—straightening, pinning, ironing, steaming, choosing, and procuring wardrobe. Here stylist Louise Godwin is making sure a stethoscope sits just right on our model. Different stylists have different strengths. Some are stronger with wardrobe, some with props, some with period props and wardrobe, and some with handling kids. It's best to match a stylist to a job that shows off his or her talents. A great stylist is one that makes the photographer look like a genius.

Those very same people also have to know when not to make a suggestion. There are times when any distraction can break my concentration, causing me to lose my moment of connection with the model. I avoid people who make suggestions just to hear the sound of their own voices.

I try to work with the same stylists, assistants, wranglers, and hair and makeup people as much as possible, viewing all as a theatrical ensemble...and sometimes a comedy troupe. When the right people get together on set, many jobs seem like a group of old friends joining up to put on a play in Uncle Fred's barn. It's a difficult balance to achieve, but when you find people who work well together, you can make magic on set.

Stylists

Other than the photographer, the most important person on a shoot is the stylist. This person is the one who can find the prop or article of clothing that often "makes" the photograph. Sometimes it's also the item that inspires the photographer to take the image in an unexpected direction.

A good stylist can make a good photographer look great by tracking down the perfect prop and bringing it to the studio on time and within budget. She'll come back with a wall clock in the shape of a cat that sets exactly the right tone for the shot; or the scarf, shirt, or dress that makes someone pop on set.

Just as some photographers are better at photographing people and some are better at still lifes, stylists have different strengths, and a good photographer will match the right stylist to the job. Some are better at wardrobe, others at propping. Some may be stronger with kids, some with finding period items. Some have several strengths.

Strangely enough, a stylist's greatest talent can be the ability to obtain the commonplace. Many times an item that I've seen a million times when I didn't need it is impossible to locate when I need it tomorrow. Try finding a lightweight, yellow cotton sweater in the middle of winter when the stores are stocking heavy wool. A great stylist will find the prize.

Don't be deceived. The job is not simply shopping, and it's not for the weak of stomach or faint of heart. Try propping a job three days before Christmas! Sometimes an art director wants something changed while we're shooting, and I'll turn to my stylist and say, "Get me a green tricycle, and be back in a half-hour!" When I throw something like that at a seasoned pro, what I get back is a comforting look of experience. What I don't want is a terrified

While stylists do the down and dirty part of getting models into wardrobe, never make the mistake of thinking of them as just a pair of hands on set. Great stylists are artists. I depend on their taste and sensibilities to help form my shots. They know what colors and styles are hot in the marketplace and how to add just the right accessory to hide a model's imperfection without making it obvious. They can make a model look "upscale" or blue collar with just a subtle change of wardrobe.

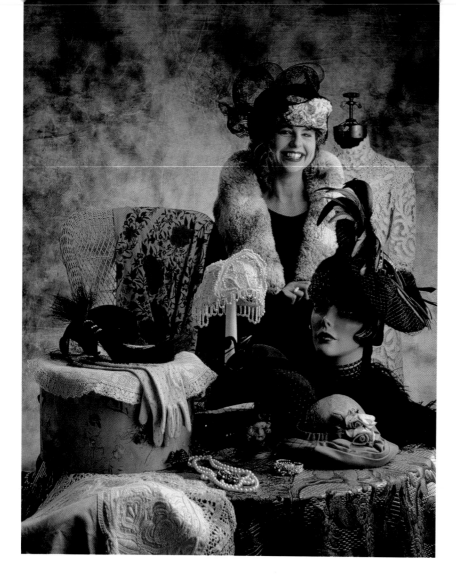

Styling a shot like this—finding great vintage clothes for a fun portrait—would be a stylist's dream job. But in this case, the woman pictured, store owner Mary Gilroy, supplied all of the clothes and the mannequin from her antique clothing shop.

look of shock and panic. A good, experienced stylist never panics, or at least never shows it on her face. I have one very good stylist who reacts to the worst situations with the widest of smiles. This is actually an asset, because the last thing I want the client thinking is that there's a problem. Clients can smell blood, and if they think I'm not on top of the game, they become terrors. As the photographer, I need to steer my ship with a steady hand. My first mate is the stylist, and it's her job to figure out how she's going to get ahold of that green tricycle in under a half-hour.

Great stylists not only have to have great style, they also have to speak your language. As a photographer you have to be able to convey exactly what you want. "Something with more oomph" is not an adequate description. Over time you build a rapport with the people you work with and linguistic shorthand can take over.

Just as the photographer asks an art director questions about a layout and how he or she envisions a photo, a good stylist will do the same with the photographer. She'll ask questions, make suggestions, and begin thinking about the nuts and bolts of putting the shot together.

The stylist is one of the first support people I call when I have to put a budget together. We go over the details of what I'll need, and we decide what budget is required to do the job. We break down the layout into its component parts to get the prices for each item we'll need. The conversation might go this way:

"Let's start with your time," I'll say. "It's a shot of one middle-aged man in a chair, looking straight at the camera.

Nothing unusual, nothing upscale—just middle-class furniture and wardrobe."

"Day to prep, half-day on set," says the stylist. "Who's the client? Big international company for a national ad, I hope?"

"No, a smaller outfit for a direct mail piece. How about $750? $500 a day for a day-and-a-half?"

"Great. Okay, we need an overstuffed chair, that's a $125 to $150 rental from the prop house...say $150. A table next to it,

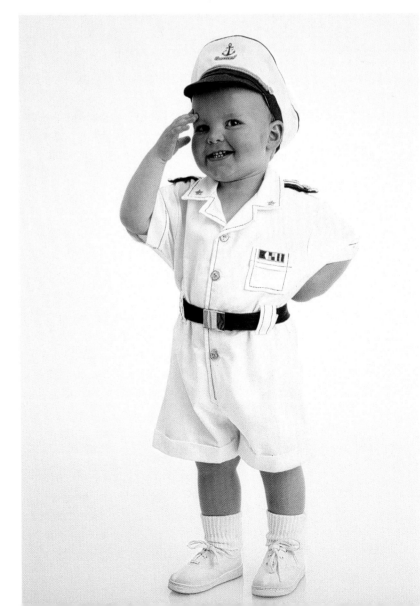

We always have models bring in wardrobe possibilities. Every so often a model comes in with something that we would otherwise never have found, and it's perfect for the shot. This boy's mother brought this sailor suit in and, of course, it fit him perfectly.

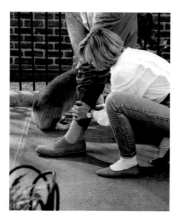

Stylists usually straighten clothes, but here is a stylist, Sandy Samardge, who is messing up a pant leg to show static cling. A stylist and photographer who work well together are almost like one person. Sometimes I start saying something, and the stylist is already jumping on set to do what I had in mind before a sound leaves my lips.

another $100, and pictures on the wall, figure $75. Do you want to get one of those old-fashioned fringed lamps to put next to the chair?"

"Great idea! Let's do it"

"An indoor plant—do you want real or artificial?"

"Artificial."

"Okay, that's $100 to rent. We need snacks on the table, say $60. Wallpaper? How big is the set?"

"I think 8 x 8 feet. It's just a single guy in a chair, so one double roll."

"That will run about $50. And let's say $125 miscellaneous for the set to find some *tchotchkes*. That'll cover any last minute things we may have overlooked."

"Wardrobe?"

"Will you see feet?" (That's always a big question, as shoes quickly run the wardrobe price up.)

"Um, they're cropped in the layout, but knowing this art director, have the model bring his shoes and let's get a pair to be safe."

"Okay, $125 wardrobe and $75 for shoes. $200 total."

"Your transportation? Say $50?"

"Yeah, just some cabs and subway fares. That'll do me."

"And for my budget for messengers, how many do you figure? Two guys for the chair, lamp, and table and then about two more trips for small items?"

"Sounds right."

"Great, I'll figure how much that'll be with ABC Messenger for my estimate."

From experience, both of us usually know the prices, but for exotic jobs, we make phone calls and do some research. For straightforward jobs like this example, I usually do the estimate without the stylist; I've done them so many times.

If I talk with a stylist about a job and ask for help with an estimate, I always try to give that stylist that job. But if a scheduling conflict makes the stylist unavailable for that shoot date and I have to give the job to someone else, most stylists understand, especially if I've worked with them before.

Assistants

My secret weapons in getting great shots are my assistants. They watch over me, behind me, all around me; they carry the equipment, set it up, and make sure everything is ready. They know what I want—sometimes before I do. They know my

quirks and my system of shooting. Without them I couldn't concentrate on the models as much as I need to in order to capture that perfect moment.

Most of my assistants are aspiring photographers. For them, assisting is basically an apprenticeship. It's hard to make a career of assisting—the hours are long and the pay isn't great—but the education you get is priceless. There is no better education in photography than being a photographer's assistant.

So what are the best traits an assistant should have? Not photography skills; those can be taught. What I want is a good attitude, drive, and enthusiasm. Most of all, I want common sense.

Really good assistants have an awareness of how their work fits into the whole, and from that perspective a good assistant can anticipate the photographer's needs, sometimes before the photographer realizes there is a need. You know you have a good assistant when you turn to ask for something...and there it is in his or her hand.

I've had assistants who worked hard and had great attitudes but were never able to see the big picture. They limited themselves to performing only the tasks they had to perform. They worried only about their specific job: loading film, keeping notes, watching the strobes go off. That is no-brain, basic assisting. Mediocre assistants see only the task assigned; they react to situations rather than anticipate them. When assisting, think about what you are doing for the photograph, and try to anticipate what the photographer might need. Think about how you would approach the job if you were the photographer. Outstanding assistants are those who think about what is going on rather than just watch things happen.

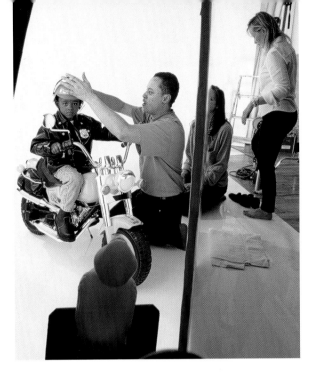

One of my long-time favorite assistants, Norman Smith, is a whirlwind on set. While my second assistant is taking care of camera needs, loading film, keeping notes, and handling the Polaroids, Norman is my second pair of eyes, making sure the product for the next shot is ready, jumping on set to help the stylist with wardrobe, and joking with the kids, the parents, and my clients to help keep a light and happy atmosphere.

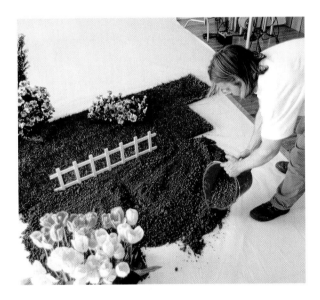

Assistants make it possible for you to concentrate on getting a great image. If you had to load your own film and dump your own dirt, you'd be too exhausted to take any photos.

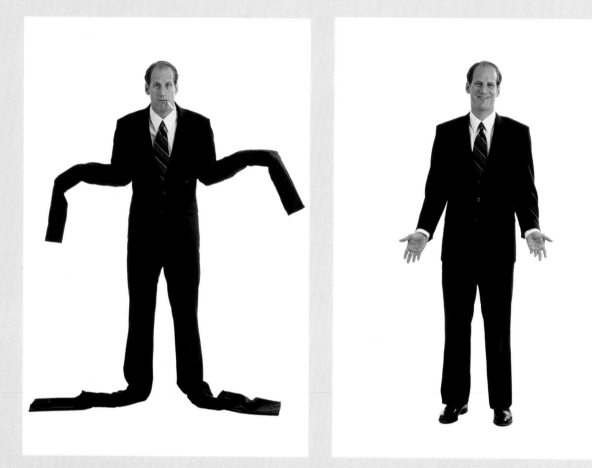

The Phone Call Always Comes on a Friday

There must be something in the air on a late Friday afternoon in summer that makes art directors call photographers and book jobs. There I am, the phone rings, and it's an old client, a nice art director who always has interesting jobs. He asks, "Can I shoot next week? And can I have a suit made in which the sleeves and pant legs are extremely long? And can I have another suit made that fits the model perfectly? And can the whole thing be produced and shot by next Friday?" That gives me five business days to do the casting and have the suits made. I say, "Maybe, but first send me the layout so I know what we need to do."

After he sends the layout sketch I realize that what we really need are three suits: one a perfect fit, and two to make the long suit (one suit would be sacrificed to provide the material for lengthening the sleeves and legs of the third suit). I tell the art director to budget for the retouching we'll need to do in order to take out the alteration seams in the lengthened suit. Doing it this way would be a lot cheaper and quicker than having two complete suits made to order. Custom making a long suit without any seams and then a perfect-length suit to match all on our tight deadline would have been too costly.

I call the costume company I've been using for made-to-order infant outfits—pumpkin kids, raincoats, football babies, baby cheerleaders, things like that. They say, "No problem!"

Now for the casting. We need to find a model with an expressive face who reads like the character the client envisions. We don't have time to have models come to the studio to have Polaroid test shots made. Instead I do a composite (or head shot) casting, and the modeling agencies send us composite cards of the type of person we want.

My timeline looks like this: Friday the art director calls to see if it's feasible to shoot. Monday afternoon I complete an estimate and send it to the ad agency. I call the modeling agencies before I get the approval in order to get the head shots on their way to the studio; they arrive at the end of the day. I edit the head shots and make my three picks. The package with picks and all the other model composites are forwarded by messenger to the art director, and he gets it Tuesday around noon. That afternoon I get a go-ahead from the agency that the budget is approved. (This is going on while my studio is full of kids for a Kids "R" Us shoot.)

The art director's away on another shoot, of course, so the art director's replacement goes through the casting with the powers that be at the agency and sends the choices overnight to the out-of-town client. The client gets the casting Wednesday morning and approves two models, a first choice and a backup. At noon on Wednesday the art director phones in the names of the models they've picked.

At this point I ask him if we can buy more time and shoot Monday morning instead of Friday afternoon, just to give us some breathing room in case we have a problem. Luckily, this time the art director says Monday morning would be OK. Good thing, as it turns out.

I send out the stylist I've hired, who's waiting to get the wardrobe. Three dark, pinstriped suits are purchased and brought to the studio. I pack two of them with a copy of the layout and instructions and send them by messenger to the costume maker's on Wednesday afternoon. The suits are done by late Thursday and arrive at the studio Friday morning at 9:30 via overnight courier.

I open the box. The pants are perfect and hysterical, but the jacket is too short. It's long, but not long enough to read as a joke. I call my contact at the costume maker's. The seamstress can fix it while a messenger waits. I call the messenger and order a round-trip rush.

The messenger walks into my studio at 4:30 with the second version of the suit. It's perfect! We book the models for Monday morning.

The shoot goes off without a hitch—actually, it's a pleasure to shoot. As with so many jobs, the production stage is where the tension is. Now, if I could only figure out why so many of these jobs begin with a phone call late on a Friday afternoon.

There's no better training for the profession than working as a photographer's assistant.

I was once working on a baby shoot, and the client asked whether there would be adequate separation between the baby's head and the background. I immediately asked my assistant to get a "net" (a scrim) for the strobe. The assistant quickly brought me a 20 x 30-inch black net scrim. That was overkill. An 8 x 10 or an 8-inch round dot scrim would have been sufficient, and either of those was what I expected. If this happens during the first few months an assistant is in my studio, I can be forgiving because I realize it's a learning process. But after an assistant has been with me a few months and has seen me do this type of scrimming, he should anticipate my needs in such a situation.

Again, common sense is the key. I've had some assistants who, after being in my studio for six months, understood the basics of how I like to light certain situations. They had the lights in position before I got on the set. Sometimes I changed the setup a bit, but at least the lights were basically in position. Those were assistants who had been watching and thinking. An assistant who, after six months, has to ask me what to do just to get started is an assistant who may have been watching but has certainly not been thinking.

A poor assistant tries to give me answers he or she thinks I want, not the answers I need. I don't care what the answer is, as long as I get correct information. I once asked a new assistant if a strobe pack was going off. He said yes a little too quickly. I knew he didn't know. So I asked if he knew that for a fact. Then he went and checked the pack, only to find that it wasn't firing. That happened once more, and that was it—I lost all confidence in him.

Telling me you don't know the answer is better than making something up—at least it's a start toward getting the right answer. If I ask, "Is that back strobe firing?" a poor assistant will answer, "I don't know." A really poor assistant will answer, "Yes," without really knowing, figuring he or she will start watching it now. Really good assistants won't answer at all—they're too busy running to the strobe to fire it. If it's not firing, they'll yell out, "No!" as they go about figuring out why. Assistants don't need to have all the answers all the time, but giving any answer just to make it appear they're on the ball is a big mistake. It can cost me a photo, which in turn can cost me a job, which can cost me a client. Ah, for want of a nail....

What are the basic skills an assistant must possess? Loading cameras, from 35mm to 8 x 10; having a basic, if not thorough, knowledge of strobes and tungsten lights; and being organized, neat, and prepared (having been a Boy or Girl Scout seems to be good experience for an assistant).

Some assistants carry assistant kits with them, containing pens, felt-tip markers, scissors, a Swiss Army knife, a compass for location trips, adhesive bandages, and a candy bar in case there's no time for a meal. Some photographers, when they're shooting, seem to live on adrenaline and can go all day without eating. Luckily for my assistants, I'm not one of those. I don't miss too many meals. But just in case, it pays to be prepared with a candy bar or two.

One thing they never tell you in school is that, as an assistant, part of your job is to make sure the photographer looks good. Sometimes that means taking the heat for something that wasn't your fault. It always looks better if the assistant gets blamed for mishaps in front of the client rather than the photographer. Once, back in my assisting days, I took the blame for something I didn't do. After the client had gone I approached the photographer and told him that the incident hadn't been my fault. He said he knew and acknowledged that it had been his fault. He thanked me for not making an issue out of it while the client was watching. He had thought I had enough sense not to make a scene about it, and he had been right.

One of my assistants explains to any new assistants working in my studio that it doesn't matter how good they look; if they don't make me look good, clients will not keep coming through the door. And if the photographer isn't working, neither are the assistants. It's amazing to me how few assistants understand this concept. Some have a very hard time suppressing their egos to boost the photographer's image. I remember reading about a famous New York columnist who said she never really got ahead in her career until she was

While the hair and makeup man touches up the model's hair, the stylist watches to see that clothes and props are in order and look natural. My assistant at "snow control" on the ladder, stands ready to make our artificial snow fall on demand by shaking the chicken-wired frame. Everyone on the crew knows their jobs, and all work together like a well-oiled machine.

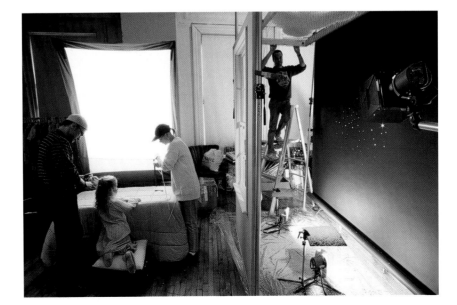

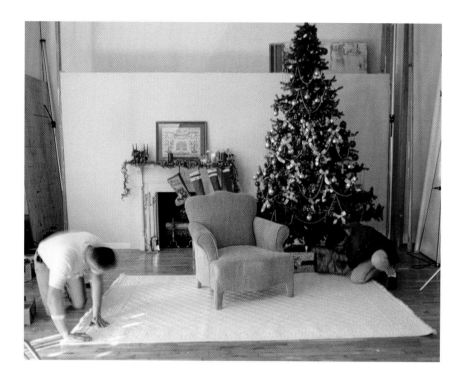

Assistants don't have to start in my studio fully armed with assisting skills and experience. Someone with good common sense can learn anything that's required. And what other profession teaches you how to hang wallpaper, lay rugs, make funny faces for kids, paint walls, and all about basic carpentry and electronics?

able to make her bosses and the people around her look good. Her philosophy of "looking out for number one" had always held her back. Being able to put aside her ego for the sake of the work is what finally propelled her forward.

That doesn't mean an assistant should be a slave or accept abuse. I've seen photographers with inflated egos and little self-esteem who felt it necessary to belittle their assistants in order to defend their status (in their own minds). If you find yourself working for such a person, I suggest you find another photographer to work for. When I was assisting, there were several photographers I just wouldn't work for if I could help it. Whenever they called, I was coincidentally booked. But I never burned any bridges. I knew that if I hit a dry spell, the egomaniac shooters wouldn't look quite so bad. Luckily, I didn't hit many dry spells.

Some photographers ask new assistants to work free for a day or two so the photographer can assess their skills. This often leads to assistants putting in two days, receiving no pay, and never getting called back for paying work, while the photographer ends up with free labor. As a brand new assistant you may work for a lot less than the going rate, but the work you do has value, and you should never work for free. Photographers who ask you to do that have no respect for assistants, and working for them won't be the learning experience you want. Rather, it will be a course in the school of hard knocks.

The corollary to that is when a potential client asks you (now a photographer) to knock your fee down to "get your foot in the door." That client has no respect for your work and will find a "better" photographer the minute he or she gets a bigger budget.

Through it all, assisting is still the best education you can get in photography. After earning my degree in photography, I thought I knew it all. Then after working a short time assisting for a top pro, I realized how little I knew. I knew how to take a photo, but very little about making photographs and producing photo shoots. If I screwed up in school, I got a bad grade and another assignment. If I screwed up in the workplace, I wouldn't eat—and I certainly would not get another assignment.

After four years of assisting, I was much better prepared to compete in the world of advertising photography. Of course, it took another three years of assisting and knocking on art directors' doors to finally get enough shooting jobs to make the transition to full-time photographer.

Baby Wranglers

When people see some of my photographs of children, they always ask me how I got those great expressions. I wish I could say it was my winning smile and sunny disposition, but my nose is long enough already. It usually involves my maniacal laugh, a toy dangling on a pole, and some soap bubbles. But the one who really makes a big difference is the baby wrangler.

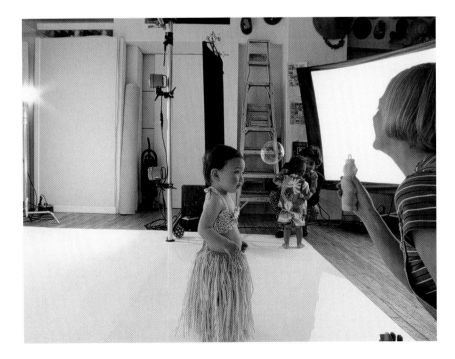

Wranglers always come to a shoot with a "bag-o-tricks." A wrangler isn't a wrangler without soap bubbles, stuffed animals, puppets, feather dusters, colored slinkys, pompoms—tools they use to hold the kids' imagination. If the kids are having fun, then I'm getting good shots.

It's impossible to tell a child, "Smile!" and expect a great smile. You have to put the smile there. That's what wranglers do—they help attach smiles to kids.

Baby wrangling isn't easy. It's a real God-given talent. You have to know what makes kids tick—when to joke, when to play games, when to get silly, and when they just need a hug. It's all about getting the kids to do what you what them to. And when the magic happens, it's transferred onto the film.

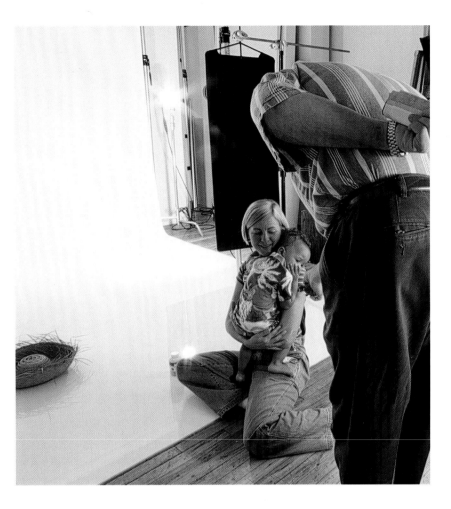

Baby wranglers are a real specialty act, but it's a job anyone with a knack for dealing with children and a willingness to make a fool of him- or herself can do. Some stylists double as wranglers, but there are also people who only like to wrangle kids. Once in a while a baby just won't like the wrangler but will take a shine to my assistant; then my assistant will get on the floor and make funny noises. We'll do whatever works—in desperation we've even turned to the parents to wrangle the baby.

On big shoots I've found that having the stylist do it all—selecting, steaming, and pressing the clothes, dressing the children, and then interacting with them—is just too much. Usually we get an assistant stylist to help. The assistant can take over the steaming, pressing, and dressing, freeing the stylist to help (me or the client) choose the clothing and wrangle the children.

Wranglers always bring their bag o' tricks with them. Universal goodies for wranglers include soap bubbles, pompoms, and hand puppets. Some wranglers even bring little treats—five-and-dime-type toys the children can keep when the shoot is over.

Often the wranglers and I interact on set to get a reaction from the children and make them relax. We might stage a playful insult-throwing fest (directed at me and the wrangler), allowing the kids to make silly comments about our faces or clothing. The wrangler might also give me "bunny ears" with her fingers or do other silly things behind my back. It's really a lot of fun to shoot children, but it's exhausting. Often shooting consists of lengthy periods of waiting around punctuated by intermittent bursts of energy. But what great photos we get!

When we shoot multiples—that is, several children at a time—the real talent of the wrangler comes out. I had one wrangler, when we had to shoot large jungle gym-type toys, issue little paper tickets to the children and then made them sit in chairs until she took their tickets and placed the kids on set. Sounds simple enough, but it seemed to calm them down before they got on set and made the shoot go easier than usual. Shooting four or five toddlers on a gym set—now there's a sight to see!

When we shoot this type of job, I often talk to the wranglers afterwards, and we always seem to agree on how the shot progressed: First up (good shots), then out of control (not too many shots), then in control again by getting them to sing together (the best shots), and then completely out of control (no shots, and time to call it a day).

The best wranglers I have are very flexible and understand that each child is unique. Some children are naturally outgoing, others are introverted. Good wranglers can bring out the best in both types by using different methods. It's the wranglers who come in with a set of fixed rules—like, "no parents on set" or "no one handles or talks to the children except me"—that I have problems with. There are no hard-and-fast rules when handling children. Flexibility and being able to change on a dime are the hallmarks of the great wranglers.

Hair and Makeup

The hair and makeup people are the most under-appreciated members of a production crew. Perhaps this is because when their job is done well, it doesn't call attention to itself. Their touch is light, and they leave no footprints, but I've had hair and makeup people add tremendously to jobs by giving models the right hair style, covering up a blemish, or making an ordinary face really bloom in front of the camera.

A hair and makeup person's role is to take all the rough edges off models and make the photos look more finished, more sophisticated. Their work should be invisible. Here, the hair and makeup man is applying the same makeup to the model's hands as she has on her face for an extreme close-up. Without doing this, it might look as if her hands didn't belong to her!

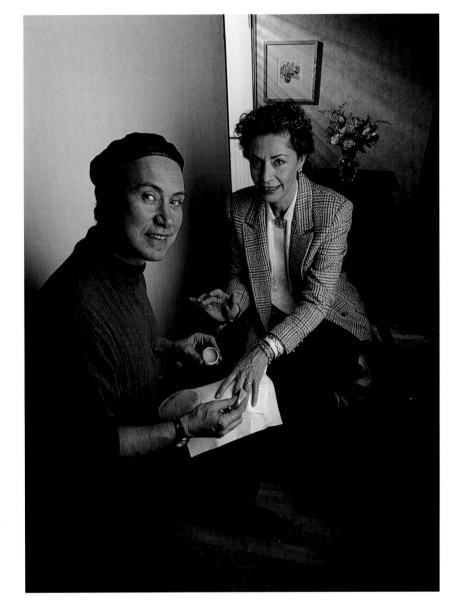

Because the job looks effortless, it's sometimes hard to explain how important it is to a budget-conscious client. A phrase I use a lot is, "You don't notice when it's there, but you sure notice when it's not." (The phrase is multi-purpose: I also use it to justify set props.)

I've seen everyone hold their breath in disbelief when a fashion model came through the door. Is this the beauty they picked? But after an hour in makeup, out comes the beauty we saw in the headsheets. Believe me, people don't wake up in the morning looking like that. If we could all have hair and makeup people work on us for an hour or two before we left home, the world would look "simply maaaavelous!"

CHAPTER 3

MODELS

Casting

One of the most important elements in the look of a photograph is the casting. If the person cast is wrong, it throws the whole photograph off. Sometimes it's obvious: Someone with a blue-collar look who is cast as a banker isn't going to work. Sometimes it's not so obvious, like a model who is expected to play the mom but isn't at ease around kids. It's amazing how quickly babies can sense when someone is not comfortable with them. ■ When I look at models' portfolios in a viewing session (known in the industry as a "go-see"), it's always easy to spot a new model who hasn't had the guiding hand of an agent to edit her portfolio or "book." Models new at the game will always have pictures that are prime examples of miscasting, like a housewife or business-woman type (a commercial look) going for a high-fashion look. Or vice versa—some models will never look like a housewife. ■ The casting process for an ad shoot begins at the client level. Clients do market research and conduct focus groups to determine how they want their product positioned or viewed in the marketplace.

Is their product targeted at a middle-aged group, youths, retirees, men, women? Is it upscale or everyday? Let's say the product they want to advertise traditionally does well in the older, middle-class market. They may decide that they want to now advertise to a younger, more upscale market. They'll tell the advertising agency that they want a campaign that appeals to a young—say, 25 to 35-year-old—upper-income market. Or they may want to continue marketing to their current audience. Either way, the advertising agency comes up with a campaign that it hopes will fill the need.

The art director, after cleverly choosing me to shoot the ad, then gives me the casting parameters. In explaining how he sees it cast, he might use real actors or characters to explain what he wants.

"Jack, we want a young, all-American type, but not too dangerous. You know, not Brad Pitt, more like a young Fred MacMurray."

I might say, "You mean more of a Tom Hanks rather than a Tom Cruise?

"Yeah, exactly—a face with rounder rather than sharper features."

In this manner, I try to understand what the art director is trying to convey. There can be a big difference between what I am told and what I perceive. I need to draw from the art director what he or she really wants in the photo.

Good models have that little extra "something" that they bring to the shoot—a look or gesture that finishes the character they are portraying. They contribute their skill and knowledge to help the photographer create a memorable photograph. This model, Jack Lotz, always asks "How's this? What about if I...? Should I try to be more funny?"

Successful mother and child shots usually require you to cast one "mom" and two or three babies. One consideration in picking the adult model is that she has to be good with children. If she's comfortable holding a squirming, squealing baby, I can concentrate on the baby's expression and not worry about giving her directions.

Later, the process of describing the cast of characters we need for the photograph is repeated again, between me and the casting agents. When I feel I know what we're aiming for, it's time to call the modeling agencies and do a casting. Large castings, in which I see a lot of models, say a hundred or more, are called "cattle calls." Agents don't really like cattle calls, and models aren't crazy about them either, but they do get the job done.

Often the cattle call is the only way to find the person with the right look. Polaroid castings have the advantage of having the models pose for the Polaroids according to the requirements of the layout. I can see what they look like from a particular angle and with a particular expression or costume. Angle is very important: I've had a couple of surprises on set when I have asked a model to turn for a profile and then watched in horror as his nose grew larger with every glance. It's something I'll miss if the model is facing forward on his composite. (Composites are a model's calling cards, with several photos showing the model in different situations.)

I once asked a model to give me a close-mouthed smile and found out that he couldn't. Every time he tried, his expression turned to a frown; it was just the way his facial muscles worked. I would not have wanted to find this out on set, with the art director and client (who flew in for the job) looking over my shoulder.

How would you describe the two very different couples in these shots? What words would you use? The industry has a shorthand for describing certain types of models. Requesting a "character couple" and an "upscale couple" will tell the agent the kinds of models I'm looking for.

When calling agents it's also helpful to discuss characters that everyone knows, like asking for a "suave, James Bond type," or a "June Cleaver housewife" or a "Snidely Whiplash banker." This will insure that the agents and I see the characters the same way, and that I'll see only the best models for the job, not just the breathing ones who fall into broad categories—like asking for "a man" for a banker role and having a 25-year-old hunk show up rather than the 40- to 50-year-old Snidely I had in mind. Agents are not mind readers, so I need to feed them as much information as I can.

For a large casting especially, I'll be as specific as I can when calling the agencies. I'll also describe the shot—the more information I can give them, the better the agents can understand what I'm looking for. I also tell them exactly how many models I want to see from each category. This helps prevent having a cast of thousands show up at my door. I've found that it's a good idea to give different agencies different times to send models, overlapping them a bit—one agent sending models from 10 AM to noon, another from 11 to 1, and so on. This also helps prevent gridlock at the door.

Large castings can become expensive. One way to lower costs is to cast from models' composite submissions. Model agents will send me a package of composites for any type of model I want, usually in

When I cast a three-generation shot, I pick models who seem to have a family resemblance on their composite cards or Polaroids. The selection is based entirely on people's perception of what a family should look like and has nothing to do with reality. When the kids come in with their real mom, their mom never looks like the model we picked!

One of the first things I ask myself before a casting is, what am I looking for? Is this a shot in which I need an expressive child, an active child, a quiet child, a gorgeous child? Sometimes I simply want the best-looking child, not the one with personality. If I want a child for a family shot, I want that child to look like he or she belongs in that family. Or if it's a fashion assignment, I might want a child who can just stand there patiently while we adjust the clothes, and then look great in them.

The fit of the clothes and the child's age are very important. Some parents wonder why I use their children for months and months then suddenly stop. They wonder if it's something they've done, if the child was bad on set, or if I am still upset that he bit me. Most of the time the reason is that the child simply outgrew the clothes and toys I was shooting and is at an "in-between" stage. I'm always waiting for a few of my favorite models to grow into the next size.

Toddlers with patience (which means about ten minutes worth) are greatly prized. Casting a patient, obedient toddler who is also a "cover" child can make me look like a genius. (Cover children are those that are so cute—with a face that jumps off the page—that the magazines put them on the cover.)

I know that if the child doesn't respond well to me and my directions during a casting, things aren't going to get any easier at the shoot. I might see one hundred to two hundred kids at a casting, and I have to size them up very quickly. I usually have children do something simple, like repeat something I say—"pizza," or "hot dog," or "French fries" (I'm big into food).

This simple repeating of a word or two can reveal a lot about a child. I can spot the shy kids, the extroverts, the cling-to-parents kids, and the self-assured youngsters.

The child's temperament is the key. I prefer outgoing kids who are comfortable with strangers; shy kids can be the worst models. It's better to have a hyper kid than one who just sits there and stares. Granted, hyper can be...well, hard to shoot, but there's such potential for great pictures! Give me a child with personality and energy any time.

During the castings, I rate the children as I see them because it helps me remember which are the ones with personality. (After the first 50 children, it's just too hard to remember who was who.) This system isn't based on looks. I shoot a Polaroid of each child so I can remember how they look. The ratings tell me how they behaved and reacted to me. The system I use is a simple three-point scale. Great children are rated #1, average children #2

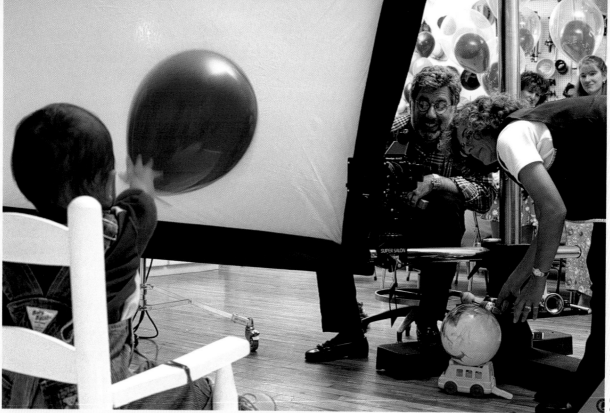

Hints for Photographing Kids and Babies

1) Be flexible! Kids will be kids, and if you can "go with the flow," you can capture some great moments.

2) Try and get your face out from behind the camera if possible. Make an effort to place your camera on a support so that you can make visual contact with the kids...unless of course the child seems scared of you. In that case, hide behind the camera.

3) Get another person to help you. I use professional "wranglers," but an assistant or even a parent will do, if they work well with the child. Anyone. It's just hard to be a one-man band when you're photographing kids. Have someone else interact with the children, and you can concentrate on shooting.

4) Allow parents on set. Never allow parents on set. See Hint #1.

5) Try to talk and relate with the child before you start shooting. Ask the parent if the child has a favorite song, a favorite toy, a good friend, anything that will help you talk with the child and have a conversation.

6) Get down to their level. Don't shoot from an adult's point of view. Get low and shoot from a child's perspective.

7) For babies and toddlers, find out when nap times are. Very important. You'll get better shots if you get on the child's schedule rather than forcing the child into your schedule.

8) Have toys and noisemakers at the ready. Soap bubbles, pompoms, and feather dusters are all "tools of the trade."

9) Have fun, and be ready to make a complete fool of yourself. A partial fool will not work. A full, complete fool behind the camera can get great photos. Kids can't fake a laugh. You or your helper (or better, both of you) have to do something funny to get a laugh.

10) Be ready to throw all these suggestions out the window at a moment's notice. See Hint #1 again.

(there's nothing wrong with #2 children; they work out fine, but I need to work harder than if they were #1 children) and children who I really don't want to see in the studio ever again are #3. I'll use fractions for those who fall in between.

When casting children, this is what I expect to hear over and over from their parents:

"Johnny loves the camera." (But obviously not my particular brand.)

"Timmy is such an actor." (So this must be his day for acting catatonic.)

"Gee, Jenny smiles all the time at home." (Well, that must be the problem—she's not home now.)

Most of the parents of the children I shoot are wonderful—great parents, good people, and they're having their children model for all the right reasons: The older kids really want to model and the younger ones are having fun. I enjoy seeing those parents as much as I enjoy photographing their children. But the stage parents, the pushy ones, while few and far between, try my patience more than any of the children.

Some kids are just so full of personality and puppy dog tails, that all they need is a little coaxing and they let loose. I always cast this little girl whenever I need a high-energy shot. I know she will always give me that wide-eyed, excited look with only a little direction.

When I saw both of these girls together, I knew I wanted a somber shot, one in which their eyes told the whole story. Rather than saying to them, "Look somber," which they wouldn't have understood, or "Look sad," because they were too young to be actresses, I just said, "Be quiet. Be very, very quiet. Don't smile."

These parents make coming to the studio a chore, almost a punishment, for the children. When it's not fun for the child, it's just that much harder for the photographer. I've had kids that I might rate as a #2 during a casting, but because of the parent I'll change their rating to a #3—meaning it's really the parent that I never want to see again. On the other hand, I've never upgraded a child because a parent has been so great. It's the child I'm photographing, not the parents.

During the shoot I always have to be in control, and I make the rules as I go along. I usually allow parents on set to watch, but if they start to distract or give directions to the child, I ask them to leave. If I feel that the parents are overbearing to their child, I don't allow them on set because they distract the child too easily.

Sometimes babies may be so attached to their parents that they suffer separation anxiety if the parents aren't nearby. In that case I have to have the parents on set, but I'm not always crazy about it. With very small babies, it's easier to work with the parents within arm's reach, and sometimes the parents work just as hard and just as effectively as the wranglers. But generally, count on the fact that parents on set are usually more of a problem than a solution.

DIRECTING CHILDREN

With the perfect child cast and the parents on my side, it's time to turn potential into great pictures—meaning that it now falls to me to direct the children, the crew, and the atmosphere. Did I say "direct the children?" Forget it. That's impossible. But what I can do is create an atmosphere on set that makes being photographed a fun experience for my young models and gives me the fun or poignant look that I want in my photos.

One of the most important rules for photographing kids for advertising is the same as for photographing any model: Get out from behind the camera. The camera's on a tripod, focus is set—it's not going to change no matter how much I play with the focus controls—so nothing says I have to look through the viewfinder in order to take the photograph. Kids need to see the photographer to interact with him (or her). Being a voice that comes from the general area of the camera doesn't work.

There is one big exception. Every once in a while I'll be photographing a child who seems to be frightened or apprehensive of me and who might react better to my baby wrangler, my assistant, a parent, or a sibling. In that situation, I'm happy to hide behind the camera. I can still direct the action, but I don't have to force myself on a child who is unsure of me. This situation sometimes happens when the child's pediatrician looks like me or has a beard. If daddy has a beard, then usually I'm loved automatically, I'm home free, but most of the time children like me because I'm a silly adult. Kids know.

Baby's first steps. What a fun job this was. First we had to find babies who had just learned to walk. Then we had to persuade the kids to walk to the model mom. Well, of the three kids we tried, one didn't work out at all, and one had just started walking and was making up for lost time. He scooted all over the set... except to "mom." Finally, we found out that this baby loved Cheerios. If you look closely at the "mom" in the final shot, you can see that her hand is cupped, holding the Cheerio treat.

79

A motion picture director was once asked by an interviewer, "How do you direct kids?" "Directing kids?" he answered, "That's easy. You can't!" How true. While you can't direct them, you can create an atmosphere on set that encourages the "magic" to happen. This gesture of baby Santa in the chimney is not something you can direct. You just have to get all the elements in place and be ready to get lucky. If you're well prepared, you can get lucky, most of the time.

As a photographer you have to be willing to do anything to get the shot, including eating a stuffed animal on set. If that's what it takes to get a smile, then pass the salt.

During a shoot I go through a lot of film anticipating when a child is about to do something. I miss a lot, but, boy when I hit, I hit big. Being observant and being flexible are both very important. I always keep my eye on the kids when they're on set. Some of the best pictures happen when a child does something impromptu and takes me somewhere I didn't expect to go. This can happen when I'm not "on," when I might be taking a break, for instance, so I always keep my eyes open. Most of the time these moments happen only once. With children, it's impossible to recreate those moments or gestures. You've just got to be there. It's a heartbreaker to get that perfect shot on Polaroid! Be there...anticipate...and be quick.

When photographing children, expect to expend some energy in order to get some energy back. The more energy I put out, the more I get back, but always in a diminishing proportion. If I give out 100 percent, I'll get back 50. What do I mean by energy? The joking, laughing, game playing, all-around fun atmosphere I have to create in the studio. Sitting behind the camera and saying, "OK, smile," or "Say cheese!" won't cut it. If I were the shy, quiet type, I know I'd find photographing kids very trying, and I'd hire surrogate extroverts—either stylists, assistants, wranglers, or in extreme need, the child's parents. As you can see from the picture of me on set, if it takes eating a stuffed animal in order to get a smile or a laugh from a child, I'll do it. Those animals are not culinary delights, believe me, but whatever it takes, I'll try it.

EXTRA HANDS

Having help on set is vitally important. I can't emphasize that enough. Photographing one baby or child isn't too hard, but as soon as I add another child or two, the complications increase exponentially, as does the number of

I keep a lot of noisemakers close at hand so I can get kids to look at the camera. You have to be careful not to make too loud a noise, though, because you can frighten them and then lose them for the entire shoot. A $2.00 train whistle is one of the better tools you can have on hand because it seems to hit that happy medium of being loud enough, but not offensive or scary to most kids. Photo © Bruce Wodder

hands I need. Even if I'm not shooting big- or even medium-budgeted advertising shots, but just personal photos, extra hands will help me get a great shot.

It's just too hard being a one-man band when photographing children. If you do, you'll be so exhausted that when that golden moment happens, it's likely that you'll be catching your breath. So I always get another person to help, even if I have to pay out of my own pocket. It makes a huge difference. (I know some clients who arrange a job's shooting schedule around a certain wrangler. Clients who work with children a lot know how important a good wrangler can be to a shoot.)

On advertising jobs, ideally I'll have several extra hands. On big jobs, I'll hire a clothing stylist to obtain the right clothes—either buying them or coordinating with the parents to bring in specific outfits and accessories. "Bright solid colors or some pastels, no patterns or logos; socks and sneakers; and ribbons for their hair" is a typical set of instructions a clothing stylist might give to a parent.

Then I'll hire a wrangler—the individual whose job it is to handle the children. (There are some stylists who are also wranglers and will do both jobs with the help of an assistant.)

The wrangling starts as the children come in the door and continues while the models are getting their hair and makeup done and their wardrobes on. It culminates on set.

A wrangler worthy of the name brings a bag with tools of the trade, some of which are duplicated in the studio. Number one on the "Tools for Photographing Kids" list are soap bubbles. Without soap bubbles I'd have a hard time calling myself a bona fide children's photographer. Soap bubbles have saved many a shoot. It's brought back children on the verge of tears and brought smiles from children who refuse to smile.

Another favorite on our toys-to-entice hit parade are pompoms. Yes, good old high school cheerleader pompoms. A close second: a feather duster. Both are excellent attention-getters and ticklers.

Next come the noise-makers: horns (I favor "aa-ooo-ga" over the simple "honk-honk" variety), bells, whistles (my best is a wooden train whistle), and a bunch of toys that make a variety of sounds. I exercise caution here, as some kids are scared of noise, and I have to keep the sound level very low. (If I'm photographing children who are the third- or fourth-born in a family, they don't even hear the noisemakers. It's quiet that scares them.)

What children's photographer hasn't seen this scene many times? You can tell when a baby's face turns that bright red color, that her modeling experience is over for the day. We can sometimes get them back smiling and laughing, but not often. As soon as we see that the kids have reached their limit, we get them off set.

Music is important, too. A tape or CD of children's tunes can prove to be very helpful during a shoot. I've heard and helped sing (off-key I might add) "The Wheels on the Bus" at least a million times. (Ah, there's nothing like the classics.) I once photographed a child who was a terror until his mom said that he loved the pop song "Just a Gigolo." Fortunately, we had a copy of it, and Baby Hyde became Sing-Along Jekyll.

For babies I have a bunch of toys that I've taped to the ends of poles. This "fishing" pole then becomes a game as the wrangler brings it in and out on set. The trick is to let the baby catch it enough times so he or she won't get frustrated. The moment before the wrangler swings the toy into the frame is the moment I get a perfect expression.

With kids two to nine years old, rather than standard toys or noisemakers, I use verbal communication. The wrangler and I engage in a dialogue in which a variety of vegetables and other foods replace various body parts. A typical conversation with one of our highly paid professional models goes like this: "Oh yeah, well you've got broccoli ears!" "Yeah, you've got a banana nose!" "Do not!" At this point I might use one of my louder noisemakers—probably the aa-ooo-ga horn.

Another favorite scenario is to have the wrangler whisper into the child's ear a "secret" that is to be yelled out to me on the wrangler's

cue. "Jack's got smelly feet!" is always on our top ten list. When I hear it, I might take off my shoes and yell, "Do not!" while the wrangler holds her nose. (We employ the most sophisticated kid's humor you can imagine.) Again, as with the songs, we never get tired of the classics, and having a handful of knock-knock jokes around never hurts.

Sometimes we have children repeat silly things—like "fuzzy pickle"—or we ask what they like on a pizza. "Pepperoni, great! How about peanut butter? No? Well how about marshmallows? What? You like marshmallows on your pizza! Ugh!" No matter the details, the tone is cheery and the voices loud.

I also possess a maniacal laugh that, fortunately, is impossible to put on paper. The wrangler will say, "Okay, Jack, give 'em 'the laugh.'" Works every time.

Sometimes babies or small children get on set and don't want to be there. The wranglers and I are very good at judging how far gone children and babies are, and whether we can get them back into cheerful moods—or at least not-crying moods. But when they hit the wall, we know there's no return. When babies get that crimson color in their faces, they don't even have to be crying—we know the tears will arrive shortly, and there's no reason to continue with that child.

Another crew person I want on set is the hair and makeup stylist. Hair and makeup can sometimes be a hard sell to new clients, but as I like to explain, "You don't see it when you have it, but, boy, do you notice it when it's not there!" Hair and makeup give me the finishing touch on my photographs. Without them, the photos look rough around the edges. A good makeup artist has a very light hand with children. Unless I'm doing a high fashion shoot, the viewer should not be aware that the child has makeup on.

If the children come in with long hair, doing their hair is a must. We've given dozens of babies their first haircut, and when an older child walks in with really long hair, I'm very grateful to have my hair and makeup stylist in the studio.

MINOR ADJUSTMENTS

Babies with earrings don't read well in advertising. When we know that the babies who will be modeling have pierced ears, we ask the parents to take the earrings off the night before.

Sometimes I want to photograph a toddler (a child over a year old) standing up...and I'm about a month too early. If it's a silhouette shot, I'll ask the parent or the wrangler to hold the child from the back. As long as all I see is an arm reaching behind the child, it's very easy to take the arm out of the photo later. I'll sometimes do the same with props or hats. I'll shoot them with an easy-to-remove arm growing out of them.

When I photograph babies or toddlers, I usually have a backup or two. For big ads I may book up to four or five babies to get one shot. For catalog shoots, I'll hire two kids, one primary and one backup. I photograph every child who's booked. If a child shows up, I take a photograph, even if I know I got what I wanted with the previous child, or even if I realize that I will not be using that child for some reason—

Here are three toddler shots. In two of them, an arm actually held the kids up. Can you tell which kid stood on his or her own? (The answer is on the next page.)

83

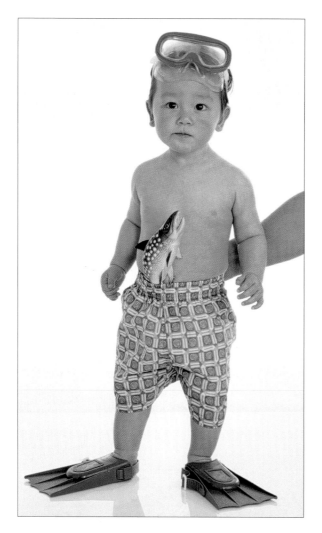

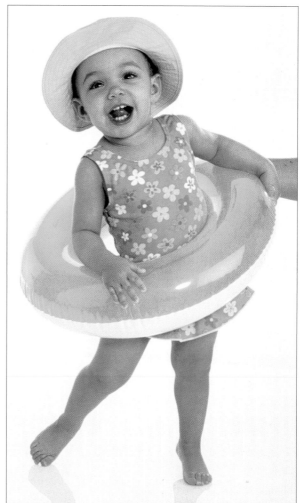

Surprise! Yes, the kid with the dumbbell was the only shot without a helping hand. But of course you knew that all along. The little boy with the fish in his pants was too young to stand by himself. So he needed a little support to keep him standing. As for the girl with the inner tube, she could stand just fine, but she just couldn't hold the tube anywhere near the right spot, so we had a stylist hold it in place while she did her best impression of a wiggleworm.

for instance, the kid's grown and is now the wrong size. Why? Because while the photo may be just another photo for me, it might be a big event for the parents (not to mention the child). They may have taken a day off from work or rearranged their schedule. They may have driven a good distance to get to the studio. I think it's important for a photographer to understand and appreciate the parents' and children's efforts. The models are important resources and assets for a photographer, and they should be treated with respect.

I photograph children because I enjoy photographing them. I believe that to be good at what you do, you have to enjoy it. The soap bubbles help, too.

The Great Photo

What makes a great photo? Several elements do it for me: composition, light, and gesture. Any one of these can make a photo an outstanding work. It's the lack of any one of these elements that can reduce the impact of a good photo. Put them all together, and you've made a powerful visual statement. Let's focus on gesture.

Gesture is that twinkle in someone's eye, a person's body language, the cocking of a head, a hand outreached. It's any and all of those "gestures" that people make that put life and soul into an image. Gesture is something I always understood instinctively, but I was not able to put a name to it until I heard the world-renowned photographer and teacher Jay Maisel use the word in describing an element in one of his photographs. Jay, a photographer's photographer, makes photographs that are colorful and brimming with gesture. As soon as I heard him use the word "gesture," it crystallized and put a label on an idea that had, until then, evaded description for me. Thanks, Jay.

There are tons of books on composition and lighting, but very few on gesture. Oh, you might find some on posing, but that's a bit different. Posing is the opposite of gesture. Gesture is that fleeting little movement of the hands or eyes that makes us instantly recognize something as being familiar and real. Posing is stiff; gesture is natural, delicate, and spontaneous. Gesture can also be bold and emotional.

Gesture is a child's body language as she looks around a door or peeks over a hedge. Gesture is a wife glancing lovingly at her newly-wed husband, or another scowling at her errant husband. Gesture is a hand placed on a friend's arm. As you can see, gesture is hard to define.

I once took a photo of a small girl making a face. I've sold that photo many times in stock. I've handed in portfolios of chromes to maga-zines, and that photo always seems to get

Gesture is that element in a photo that makes the person in a photograph human. Without those humanistic elements you may as well shoot stuffed mannequins. Gesture can be as important as lighting or composition.

It's gesture that makes this photograph. When I asked this little girl to turn around very quickly, she did it and really enjoyed it. Her hair flying is just part of the photo's strength; it's her expression of sheer joy that makes it a great shot.

picked. Why? I wish I knew. My best guess is it's her gesture. The lighting isn't a knockout, the composition is nothing special. It's a basic portrait-type shot. The gesture is what makes it unique.

Gesture is extremely important, and it's the most fragile, fleeting part of many photographs. When working with models, especially less-experienced ones, I find they do the most natural, visually exciting gestures and poses when I'm not shooting. Usually I'll see them doing something with their hands or posture while we're waiting for the Polaroid to develop or while we're moving lights. The trick is to get them to repeat it for the camera. Sometimes it's their hand placement, sometimes it's their posture, less rigid and more relaxed. Sometimes it's their body language.

Body language is very important in photographs. Many times in order to get models to look natural in a photo, I have to place them closer to each other than their comfort zones permit. If someone is talking, is that person leaning in? Is the listener leaning away? That's body language—it's non-verbal communication—and reading it and using it is one of the keys to making great photographs. You have to get the message across without using words. And that is what makes gesture so important.

The most "anti-gesture" photos can be found on ads in hotel elevators. You know the scene: Two couples sitting at a table in the hotel's restaurant, a waiter standing over them to take their order. But something's wrong: Aliens have taken over their bodies! You can tell because they all have the same stupid smile on their faces. Not one of them looks natural and relaxed. You can tell by the waiter's body language that someone has nailed his shoes to the floor. No one is talking. They can't—their faces are frozen in those awful, strained smiles.

If I had to shoot that picture, I would have the models act out a scene with one person talking and another answering. It would take a lot of energy to get them to act naturally. To get them to smile, I might tell the "waiter" before he goes on set to tell everyone the specials for the day. I'd have him say, "And today we have boiled chicken feet in a delicious, creamy gravy. And you're in luck, the chef ran over a possum on the way to work, so we know the chef's special will be possum à la Chef Irving," and so on. You get the idea. If the other models are good, they get right into the swing of things

This photo can be interpreted in many different ways. Does it convey surprise at receiving a new puppy dog, wonderment at seeing his first giraffe, or has he just broken a lamp with his baseball?

The trick to getting genuine expressions from people is to have them carry on a real conversation. Absolutely nothing looks more phony than people mouthing words with nothing coming out. After a while, with some conversational cues from the photographer, the models usually loosen up.

and ask "What is the sauce for the mystery meat special today?" and "Does the chef prepare his possum braised or boiled?" The sillier the better, as that will get everyone more relaxed and more interactive. I know I've gotten a great photo when I have to shout to the models that we're done because they got into it so much. They basically forgot I was there.

Over the years there have been many fashionable styles in advertising photography. Comedy and Norman Rockwell Americana were very popular more than a decade ago. At the end of the eighties high fashion photography and its sensibility was the rage. A lot of advertising was done with a fashion photography feel. I always joked at the time that if I wanted more work, I would change my name to Jacques, and that alone would bring more people knocking at my door.

Lately gesture seems to be the rage. You've seen the photos. They're slightly (or greatly) out of focus, at a tilt, watching people at a "caught" moment. The photos appear to be more photojournalistic than posed. More and more art buyers are asking for samples that are "not posed." The more relaxed, of the moment, and candid, the better. Who knows, maybe in a few years the pendulum will swing back to posed photos. The stiffer the better. It would be a fifties retro

look. (Actually, that look came back for a very short time, and I did a José Cuervo job that mimicked that fifties, stiff-as-a-board style.)

I think that in order to be a good people shooter, you need to study people and their gestures. What makes one gesture better than another? What looks more natural? What doesn't look natural at all? Watch, observe, and develop a feel for what looks natural and what doesn't.

That's why I enjoy shooting dancers more than any other models. No matter the situation, dancers understand gesture. They practice it, they fine tune it. To watch a good dance troupe is to watch a concert of gesture.

This photo is a very compelling portrait of a face that saw World War II from the inside of a concentration camp. It tells a story. I saw the early evening light on his face and held my camera very, very steady. I told him not to smile and to place his head on his hand. It's a very expressive image.

CHAPTER 4

TECHNIQUE

Propping

Okay, you have the great set built or the great backdrop painted, and the models are all picked,...but something's missing. Of course, the props! A prop can be the centerpiece of the shot or merely that little thing you don't notice until it's not there. In either case, props can help or hinder, make or break a shot. ■ My attitude about props is this: Don't fall in love with a prop unless it is, in fact, the focus of the shot. Unless the prop is the item the photo is selling, props are background pieces, especially when you're shooting people. In fashion photography the clothes are paramount—the models are there to create mood and provide something to hang the clothes on. In illustration photography, the models and what they do are important. Their clothes are just props that help create the mood and tell the story. ■ Attention to detail is vital in propping. It's the little figurine in grandma's living room or the cat asleep next to the family computer (props don't have to be inanimate) that makes the shot realistic. It's the framed picture on the wall, the type of pen held by the doctor.

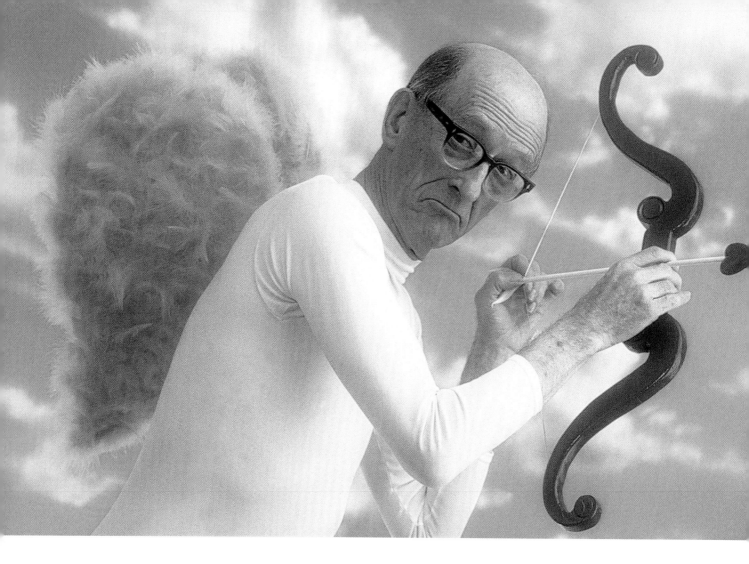

The right props can make a shot. The props you use have to read quickly and establish the scene. A hunting bow or a child's bow just wouldn't have worked in this shot. This bow was very hard to find, but once we found it, we knew it was the perfect touch to help make the final photo read as Cupid.

Sometimes a carefully chosen prop ends up being unrecognizable in the final shot, but without it, I would never have gotten the shot. While not always the centerpiece, a prop can sometimes be the inspiration or the catalyst that moves a photographer to create a great photograph. The photo of the boy with the violin on page 99 wouldn't have happened if I hadn't spotted a wooden chair in an antique shop. While not vital to the shot visually, without that chair I wouldn't have put the elements of the photo together. The chair was the catalyst, my muse, so to speak.

Sometimes, of course, props are there just for visual clutter; without them, the shot would look too stark, unnatural.

Usually I have a prop stylist obtain the props for my sets. I give her a detailed description of what I'm looking for and then she adds her own taste to the mix. With a stylist I've worked with for many years, this is usually an easy process. "I want a contemporary glass, not too funky, but not old-fashioned. Something in a primary or bright color." With those rather vague instructions, the stylist goes a-huntin' and finds something fantastic.

Of course, the trick is not only to find it, but find it on time and within budget. Give someone two weeks to find a dozen-plus items, no problem. Give her a day and watch what happens. My rep once

said that she would help find a blouse for a shot I was doing the next day. After all, she was a Shopper, with a capital S. Well, after she'd spent several hours in several stores looking for just the right cut and color, she called the studio to give us the good news: She'd found it. That's when I had to tell her the bad news: The art director decided to change the color scheme; now we needed a different color. That was the last time she volunteered to help prop a shot.

What makes a good prop? That depends on what I'm trying to do. Let's say I need a living room chair. Now, what kind of chair? Is the look upscale, blue collar, modern, period, Early American, or Shaker? Should it be light in color, or dark? Maybe pastel? Patterned? Gingham? For an upscale shot, the props have to read upscale, so bargain hunting won't do. And to get a middle-income look, shopping at Tiffany's won't do. Which brings me to the next set of questions: Where will I get this prop? Will the store deliver it to the studio, or do I have to have it picked up? Can I rent it or do I have to buy it? Is the cost, including delivery, within my budget? And then the biggest question is: Can I get it in time? If the perfect prop isn't available until next week, and I'm shooting tomorrow, then the prop is non-existent. Therefore, a so-so prop that's here right now suddenly looks more like a swan than an ugly duckling.

The hat in this portrait is just a secondary prop, but without it, the photo would have been entirely different. It would have had a different mood and lost its mystery. Why the hat? Where is she going? Is she dressed up for a party, a dinner, a date? Even though you may not ask those questions consciously, the intrigue still exists. Without the hat, this photo would have been just a woman's profile.

You have to be very conscious of how your props play together on set. Matching the right suit to the right couch can produce strikingly different effects. I felt that the dark couch would work well as long as the model wore a contrasting suit. Another photographer might have picked a dark suit to get a monochromatic look. And a third photographer might have picked a white suit to make a bold statement about the model.

There are companies that will often lend their products in return for a credit line, or sometimes they just want the exposure. I once called the public relations department at Mercedes Benz because I was desperate to get a red Mercedes convertible for a shot. I was hoping to just get a lead on a dealer who could rent me one. It turned out they let me borrow their promotional car, which happened to be a red convertible. Not only was there no charge, but they let me drive it from their offices in New Jersey. What fun! Of course, I did have to show them the layout ahead of time for their approval.

There is no reluctance on our part to make sure that the art director gets exactly what he or she wants. The stylist did a great job of finding wallpaper that was nearly identical to what was called for in the layout.

Some department stores also rent items, sometimes at a percentage of the retail price. Clothing stores might require that I keep 20 percent of what I bought for the shoot, meaning that I can return 80 percent of the purchases.

Some national chains can be very helpful when it comes to locating things like wallpaper. They can check their stores nationwide and let me know who has the particular pattern I'm looking for. With the help of overnight delivery, I have it the next day rather than having to wait weeks for an order to come in. (It always pays to do research over the phone.)

Of course, good stylists know all these things, which is why they're so valuable to the production of a photograph.

That said, nothing is as thrilling as walking into a store, flea market, or garage sale and spotting a prop that just screams to be shot—a prop to build a shoot around. Maybe it's a baby carriage, an umbrella, an antique office fan. Many times a prop that pushes me to shoot something just disappears into the shot. It's served its purpose—to stimulate me—and it's now just a soldier in the field.

This shot of "Harry James" and his orchestra was for a direct mail piece selling old-time band recordings for Reader's Digest, and the budget wasn't huge. The important elements, like the instruments, tuxes, and bandstand, were actually very easy to find. The problem was getting the "HJ" letters. When it came time to shoot, they hadn't arrived from our custom press-type supplier. The clock was ticking. They finally arrived by messenger with less than a half-hour to go. We quickly applied the letters and finished on time, but it was close.

Rent or buy? When you're running a studio, sometimes it isn't practical to buy certain props. The big questions you need to ask yourself are: Where will you store them, and how often will you use them? If you buy a prop, not only do you have to pay the full price, but storage costs money, and the more clutter you have, the harder it is to find anything. One year I had to rent these theater seats three times, and I haven't needed them since. On the other hand, there are props that you may use every month of every year. In that case, it might pay to purchase them outright.

Most of my prop hunts are combined efforts by my stylist and studio staff. Often we'll split the assignment to make it more efficient. Living in the country, I might have better access to certain props—say, an old-fashioned, red-flagged mailbox on a post—than my stylist who lives in Manhattan.

I make mental notes when I discover a store that carries lots of unusual things. The owners of an antique shop near my house specialize in buying out households. They always have interesting things, and they've been a good source of props for many of my shots. Salvation Army stores and thrift shops are good sources for items that don't have that brand-new, just-out-of-the-box look. I also keep a mental note of what's available in the neighborhood around my studio. Remembering that there's a store that sells men's shirts or women's shoes or stuffed owls can prove valuable when the art director asks, "Say, can we make that a green shirt on the guy, and yellow sneakers on the woman, and can we get a stuffed animal somewhere?" I can hear you laughing, but it happens, and it happens while models are on set with the meter running.

I also maintain large prop and wardrobe rooms in my studio, and I rent storage space in the basement of my building for even more props. There are certain props you just know you're going to use: men's khaki pants, women's plaid shirts, a computer. Years ago I bought a broken computer from a repair center to use as a prop. It doesn't turn on, but I've rented it to myself on occasion. (Yes, I will rent props to myself and bill my client; it costs money to acquire the props and store them until they're needed. Besides, I charge much less than the rental houses, and there is no messenger bill for pick-up and delivery.)

There are also great prop houses in New York City, companies that gather often-used props—such as tables, sofas, kitchen things, office stuff—and rent them to photographers, TV studios, and motion picture producers. It's fun to spot a distinct prop, like a family picture on the wall or a familiar chair, that I've used in one of my photos in a Woody Allen film or a *Saturday Night Live* skit. There are some items I've rented so often, like a particular over-stuffed club chair, that I know I've paid for them several times over. But it's still cheaper per client to rent items like these as needed rather than to buy and store them.

The one thing that many photographers forget to check is whether a prop will fit into the freight elevator and through the door to their studio. I just have a standard door but we've squeezed in a Harley Davidson, a dentist's chair, and even this baby grand piano (the legs came off and it was rolled through the door on its side). The only prop that didn't make it was a hot air balloon basket—it was just too big and too rigid. So I always ask for the dimensions of props. It's very expensive to have a prop delivered and then pay to have it returned without ever having used it.

Testing, Testing

Professors know that it's "publish or perish." The photographic equivalent is "test or termi-nate." Test your abilities. Test your imagination. Test out new equipment, test for the sheer joy if it, test to produce pictures for a portfolio, test to see what can be accomplished. It doesn't matter why...just test! When I test, there's no client and no art director telling me what he wants. I have complete control and absolute freedom.

For a long time I had wanted to do a test with a stylist I had worked with on many jobs. One day I saw a chair in an antique shop and used it as my catalyst to do a test with her. She and I collaborated on which model to use, which props, and which clothing would look right. The chair was originally intended to be the most important graphic element in the shot, but as the pieces came together, it seemed better to have the chair be just a small part of the shot, rather than trying to force it to be more important.

This shoot was fairly straightforward. I used only one light, a large Chimera bank, and placed it off to the right. By rotating the bank on its stand I adjusted the light hitting the background until I got the mix of light and dark that I liked. Most of the time I try to light the background separately, using different lights than I use for the subject. That helps create a separation between the model and the background so that the model stands out. But here, as a test, I tried something different, and it worked out quite well.

Another thing I was testing was a 90mm f/2.8 tilt-shift lens I'd just gotten for my Canon EOS-1N. I shot the model and his violin with both the tilt-shift and a regular lens to see the difference. Tilt-shift lenses were first developed to correct distortion when shooting architec-tural images. But here I used the tilt-shift lens to minimize my depth of field. The tilt-shift definitely added to the shot—the shallow depth of field helped lead the viewer's eye up to his face and his violin.

Finding the correct amount and direction of tilt is basically done through trial and error. The principles of view camera tilts and swings are governed by the Scheimpflug Rule, which states that focus is maximized if the film plane, the lens plane, and the subject plane all converge at a common line. (Makes your hair hurt, doesn't it?) If you under-stand the Scheimpflug Rule, you'll understand the hows and whys of this lens. In reality, when a tilt-shift lens is used for creative rather than corrective applications, I feel that just playing with the lens and then looking at the results on film is much more helpful than following any rule.

All in all, this is what testing is about—trying new techniques and hopefully getting a new photo for your portfolio. I got a lot of great shots out of this test. Canon USA thought so, too, as one was used on the cover of their book, *Explorers of Light.*

The color of light is very important in setting a mood, especially with a night shot. Blue light evokes a sense of nighttime, and orange light gives the feeling of warmth. Even though this shot looks as if it was lit only by the table lamp, we actually used several strobe lights and gels to create the mood. The models were lit by a strobe with a warming gel, and the shadows were filled in with another light with a blue gel. We also used a light on the back wall and put a spotlight on the digital clock. Finally, we put a small strobe light with a warming gel in the lamp to make it seem like the source of the light.

Lighting

Light is at the core of what I do. By manipulating light, I create mood and feeling in my photographs. By putting a blue gel over my fill lights, I invoke the feeling of a cold night; by warming my main light with a golden amber gel, I can make the viewer feel warm sunshine. You can have the best camera, lens, and subject, but without good light, you don't have a good photograph. Light can be the most important element in a photograph, and the ability to control light and lighting are what separate great photographers from good ones.

The biggest mistake photographers make when reading a book like this is to set up their lights in exactly the same way as is shown in the book's diagrams and then not look at the light output and not move or adjust the lights at all. Lights are never formula driven; light should be massaged, noodled, flagged, and netted to produce the quality an individual photographer wants. Great lighting may be several stops away from what a light meter says is a "correct" exposure. You may need to open up or close down one, two, or even three stops to get the light you want. Lighting is truly a case of having the ends justify the means.

Once I set up my lights, I take a Polaroid shot of the scene. The Polaroid is my sketch pad, and I'll move my lights and fiddle with nets and flags to alter the light, or I'll gel the lights until I get the color of light I want. All the while I'll shoot Polaroids to visually check my progress. Is the light too soft, too harsh, too light, too dark? Do I need to move it closer to or farther from the subject? Is the source too big or too small?

It's funny, but some days the lighting gods smile, and every move is blessed by beautiful radiant light falling on the subject, reflecting back to the camera and onto the film. Then there are days that make me think I should have sacrificed a chicken. Nothing seems to work. The Polaroids peel back, mocking my best efforts. The lighting gods are not happy. But at that point I'm halfway there! Knowing when lighting doesn't look good is half the battle. Knowing what is not working means I'm getting closer to what I want.

To get this type of high key look I used four Dyna-Lite heads split between two 1,000-watt-second power packs and a large light bank connected to its own 1,000-watt-second power pack. I wanted most of the light to come from the background, lighting the white fabric, so I placed the Dyna-Lites just behind the model, on either side of her, and pointed them directly at the background. I was careful not to toe the lights in toward the center so their light wouldn't spill onto the model. The light bank was placed in front of the model, to one side of the camera, and set at 1/2 to 1/4 power of the back power packs so it could act as gentle fill. Polaroids are useful in determining the exact balance. You can often get some low-level flare with shots like this, but because of the quality of the coating on the Mamiya lenses I was using, I had none.

This photo was done on assignment for an in-flight airline magazine article on Boston restaurants. I was shooting with my Canon EOS-1N, an 85mm f/1.2 lens, and a small Canon Speedlite attached to the hot shoe. I set the shutter to about 1/8 second so the ambient light would register. The strobe was set back a stop or more and pointed at the ceiling, using its small built-in reflector, so the flash wouldn't overwhelm the shot. I saw the waiter walk by quickly, I followed him, and shot, getting this energetic image with a lot of ambiance.

The one thing I never do is just set up my lights, take a meter reading, and shoot. That method gives me the correct exposure, but not necessarily the best photo. To get a great photo, I have to know that the quality of the light I set up is great. Just having the correct exposure is not enough. When I was a student, just getting a decent exposure was enough. Heck, it was even thrilling! But not as a pro. I need to know if the lights are giving me the effect I want.

I always look at what I've got. I study it...question it. Is this the effect I really want? Will it look better lighter? Will it look better darker? Is a corner too bright? How can I darken it? These are all questions I ask myself as I shoot. That's why it's not unusual to see a photographer, or any creative person, talking to himself out loud to work his way through a problem. Crazy as it sounds, that helps more than copying lighting formulas from a book and following them blindly. Play, experiment, have fun, make mistakes.

That's how to learn lighting. Complacency and a willingness to accept "close enough" can be what separates you from an outstanding photographer.

Now let me show you how I light some of my photographs. Most of the time I don't need to begin with a meter reading. After years of working with studio strobes, I have a good idea of what the basic exposure will be based on the power at which I've set my lights. I just wet my index finger, hold it straight up and say, "f/16 and a half," and son-of-a-gun if I'm not correct within a half stop! It's not magic; there's no secret to it. It just comes from having a lot of experience working with strobes, looking at the results over a long period of time, and knowing, for instance, that if my strobes are all at full power, with one strobe down a stop in the back of the set, my exposure will be in a certain neighborhood.

One light. That's it, one light. But it's not as simple as it seems. I used a grid spot to control the light's spill and direction and several cards to block and modulate the light on the models. I played with the cards and nets the same way one would dodge in the darkroom. The only difference is, when you dodge with a card on set, the area you block is darkened.

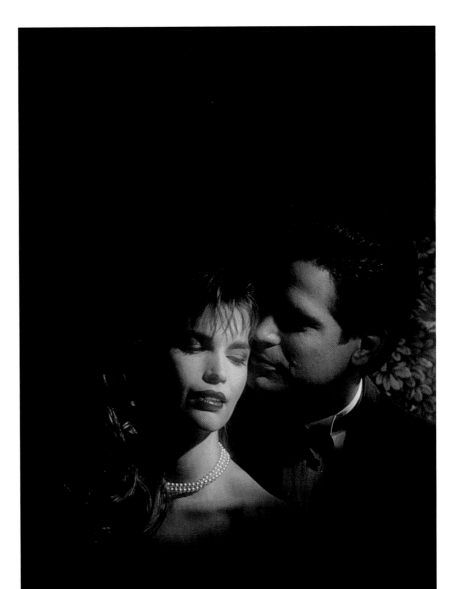

Besides, a light meter just tells me the exposure based on reading 18 percent gray, and that exposure may not be what I want for the final effect of the photograph. And even if the meter gives me a good overall exposure, it doesn't tell me what the light looks like. I've taken meter readings in the studio that just confuse me. They tell me I should open up a stop and a half, while the Polaroids tell me that I'm right on for the look I want. That's when I put the meter in a drawer. On location, it's another story. When the sun is setting, who has time for a Polaroid? I want an assistant with a meter giving me a reading every few minutes.

I have friends who work the opposite of the way I do. Polaroids confuse them; a hand-held meter is their lifeline—and their work is gorgeous. I'll state it over and over again: There is no one way. Whatever works for you and gives you the results you want is absolutely the right way *for you*. I am simply explaining the way I do things.

I'm a visual person, and by looking at a Polaroid I can tell that I want a light moved in six inches to give the subject a bit more oomph. ("Oomph" is the highly technical term one hears from a client; it's similar to "The light needs to *sing* more.") Or I may use a flag or a net to control the light in a specific area. A flag is a solid card that does not let any light pass through it. A net is black netting that allows some light to pass through. Nets come in a variety of shapes and sizes and offer different degrees of light transmission. (The nets and flags I use are made by Matthews, a Hollywood company that makes stands and lighting equipment for the film industry.)

We shot this real family on location in their loft. The "sunlight" was actually a Dyna-Lite 2040 strobe head, pointed at them from their left. A reflector card was placed at their right, and by moving it various distances from the subjects, I was able to control the light ratio. That's it for lighting—one strobe head and one reflector. Very easy.

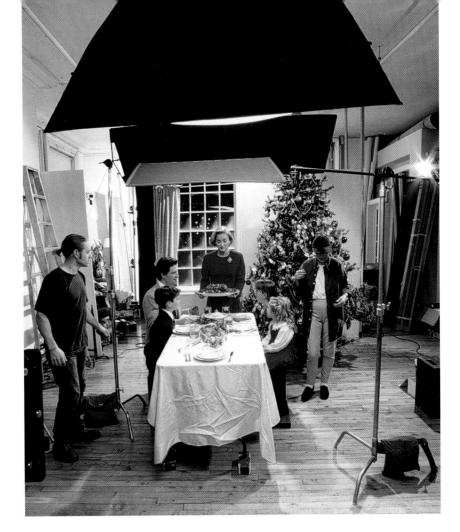

Even though the larger bank light looks like the biggest light in this shot, it actually has the smallest amount of output. One of the Dyna-Lite strobe heads at the back of the set is my main light. The overhead bank is just a giant fill light used to make sure the shadows from the very directional main light don't get too dark.

If an area is getting too much light it may need to be flagged off, or it may be better to use a net when shooting a portrait, for instance if the light is too bright ("hot") on the subject's shoulder. The net will reduce the light on the shoulder without affecting the light falling on the subject's face. If I were to use a flag, it would create too dark a shadow, unless of course that is the effect I am looking for. Flags and nets are tricks of the trade that are commonly used by most pros, and the difference between *taking* photos and *making* photos can be determined in part by whether one undertakes that kind of precise manipulation.

As I said, what's important is the ability to see that what you've got is not good enough and that you need to improve it. My ideal situation when shooting a one-hour job is to fiddle with the light for 45 minutes and shoot for 15. On some jobs I might take several hours to fine-tune lights that we had already worked on the day before. There is no reason to shoot if the light is not the way I want it. Once the light is set, then I know I can concentrate on getting what I want. If the light is not set perfectly, no magic will suddenly happen between the time I snap the shutter and the time the film comes back from the lab. The magic has to start with getting the lighting right, and the rest of the magic comes from what you do to direct the shot.

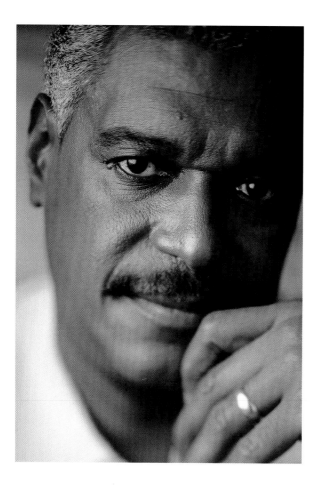

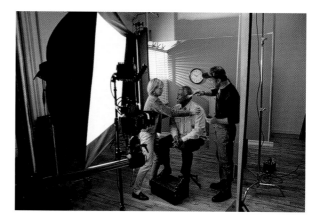

This portrait is part of an ongoing series for Tylenol. The assignment is to shoot extreme close-ups—before-and-after shots—of people who take Tylenol. The art director, Steve Close, allows me to shoot them as dramatic portraits. As we've progressed, they have become more and more dramatic. This portrait was done early in the campaign. Lighting it was fairly simple; I just used one large bank light very close to the model. I positioned the bank horizontally instead of vertically so I could wrap the light slightly onto his face to get a catchlight in his eye in shadow. To get the deep, dark shadow on the side of his face, I used a 4 x 8-foot black reflector.

Let's start with my most basic lighting setup, the one I've used for a majority of the photos in this book. One light: a bank light with a white or black reflector. By moving the light closer to or farther from the subject, I control the size of the main light that falls on the subject. The smaller the light source, the sharper and darker the shadows. OK, now forget all that. Just use your eyes and look. What is the quality of the light as it gets closer to or farther from the subject? I'll give you a clue: The closer the better for a head shot. In most of my people photos, if you were to move the camera just a little, you would see the light source in the frame. My main light is always just out of frame. A lot of people like to place their main light a good distance from the model and open up to get the "correct" exposure. That effect is fine, but it's not one that I prefer. I'm not saying that my

way is the best way, it's just my way. You need to find out what works for you.

Now, I don't care if my lighting ratio is 1:2, 1:3, 1:9, or 1:12. I only care what it looks like. Is that shadow as light or as dark as I want? While I'm trying to balance my lights to get that perfect 1:3 ratio, my model's losing interest at a rate of 1:100! I was taught lighting ratios, and I understand them, but I don't get hung up on them. I've never had a commercial client tell me, "We want at least a 1:4 ratio on the model." More likely they say, "Hey, can you make it more dramatic?" or "Hey, can you, you know, do something, kinda like, you know, *more*?" It's up to me to think, "Yeah, 1:12," and say to the client, "Sure, I can make it more dramatic and give it more oomph." In short, I look and see. (Actually, "look and see" sort of distills this whole section.)

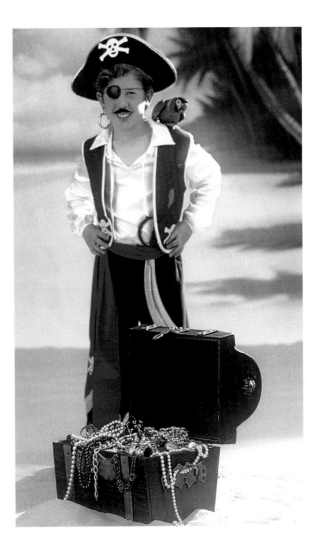

A lot of times I'll have a client who wants me to shoot in the studio during a "shoulder" season—like the month of March, when it's not quite winter, but here in the Northeast it's not quite spring either. An outdoor shot in March or a garden shot in April can be iffy. I'll give you a few examples of "sunlit" shots done in the studio.

In shooting this illustration (right) of what a boy would dream after falling asleep reading *Treasure Island*, I wanted the fantasy to look as real as possible. That meant I needed to simulate bright, tropical sunlight. To do this, I broke the set into two parts: foreground (the boy), and background (the painted canvas beach scene). By lighting both individually, I had more control and could make it look more authentic. To light the boy, I placed a single strobe at the back right of the set and pointed it at him. (Notice the backlight on his elbow and the drop shadow in front of the chest.) Two 4 x 8-foot foamcore reflectors were placed in front of the model on both sides to throw the main light back into the shadow. I took a Polaroid and set the exposure for the shadow, not the highlight. I wanted to open up the exposure so that the shadow would be as bright as it would be in daylight. To evenly illuminate the background I set up five Dyna-Lite heads on an AutoPole frame and pointed them directly at the backdrop. Some of their light spilled into the foreground, acting as fill.

The woman gardening (page 108) was shot in the middle of April, about two weeks after an unusually late snowstorm and two days before an even more unusual last-gasp snowstorm. The shot was done as a pharmaceutical trade ad. I had done similar shots several times before, and I knew exactly how to approach it.

The propping was fairly straightforward. We brought in shrubs, as well as a mixture of real and silk plants, for the foreground and background. Although they didn't show in the final

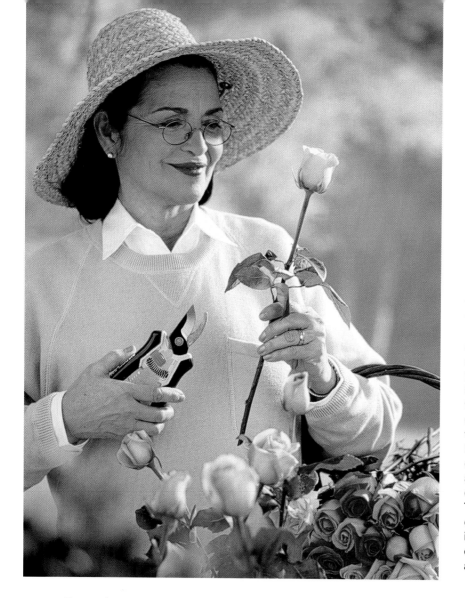

This simple and straightforward shot is a natural to do outdoors. But if you have to shoot it in New York City in a snowstorm...time to haul out the painted backdrops and dust off the "outdoor" lighting.

For this shot I used a Lee CTO warming gel over the main "sun" light, which was placed at the back right of the set. The background was lit separately with four Dyna-Lite heads pointed directly at the backdrop and placed just behind the model. For fill I made a large 8 x 8-foot reflector wall from two sheets of foamcore. I wanted to make sure that this shot was very open in the shadows and had an overall lightness to it, so I also bounced a strobe head off my 12-foot white ceiling. To achieve the desired depth of field, I had to use every inch of my 38-foot-long studio and use a very wide aperture on a long lens.

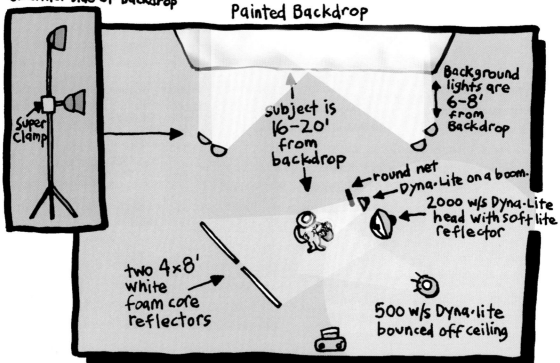

two 500 w/s Dyna-lite heads on either side of backdrop

Painted Backdrop

Super Clamp

subject is 16-20' from backdrop

Background lights are 6-8' from Backdrop

round net
Dyna-Lite on a boom.

2000 w/s Dyna-Lite head with soft lite reflector

two 4x8' white foam core reflectors

500 w/s Dyna-lite bounced off ceiling

shot, having extra props is a worthwhile precaution. It's better to have too much than to run short.

Several lights were used to have it look sunlit. (I use Dyna-Lite strobes.) My main light was a single strobe head with a soft lite reflector set at 2,000 watt-seconds. It was pointed directly at the model from the back right side and gelled with a slight warming gel.

There is a light on a boom, directly behind and above the model's head. I added it at the last minute to give more light to her shoulders and help separate her from the background. You could call it my shoulder light. I didn't want that light to burn out the edge of her hat, so I placed a round net in front of it to cut down the light

hitting her hat while still keeping full light on her shoulders. To keep the light on the model "open," a 500 watt-second Dyna-Lite was bounced off the ceiling. I also used an 8 x 8-foot fill wall (made of two 4 x 8-foot sheets of white foamcore) to reflect light back into the shadows. This fill wall was placed to the left of the set.

There are also four Dyna-Lite heads pointed at the background. One key to making this type of lighting look real is to balance the background and subject illumination. You can even overexpose the background, but if the background is darker than the subject, the scene will not look like it was shot outdoors.

And there you go, sunlight in the studio on a gray spring day.

This shot was done in an outdoor swimming pool on the top floor of a hotel in New York. It looks like natural light, and it is, with the addition of two round, fold-up reflectors on either side of the camera. Sounds simple enough, until you find out that the client wants it shot in 4 x 5. The problem lies in using a large aperture to shoot a backlit subject outside. Some of the shots were bound to be out of focus. In addition, the water kept moving, making the model drift out of the range of focus. With 35mm this would not have been a problem, but with 4 x 5, it was a headache. I attached a string to the camera, knotted it exactly at the model's point of focus, and then refocused while the model held the knot to his nose. After about two 4 x 5 holders or so, we opened the lens and rechecked the focus on the ground glass. It worked quite well—only one out of four shots was out of focus—a better average than I expected.

For this "outdoor" studio shot I used a single strobe head in the back of the set with a 4 x 8 white foamcore opposite it, in front of the model. I placed the foamcore reflector as close to the model as I could. The shot was looking a little too contrasty, so I also used a large light bank to help fill the shadows and open up the lighting a bit more. I wanted to have the bank be weak enough so that it didn't register as a separate light source. Another thing to be very careful about in backlit situations is flare. Strategically placed gobos (black cards that "go between" the light source and the lens) prevent image-deteriorating light from hitting the lens.

The golfer's feet, done for a bank ad, was shot similarly. One main light was pointed directly at the model's feet, from his back left side. I used a reflector on the right front to fill in and a light bank set low and to the left, just as a gentle fill so the shot didn't get too dark.

While some lighting is very simple, some photos just *look* simple—and it can take many lights to make that photo look simple.

For the woman at the computer, I had to use two lights to create the screen's glowing effect. I wanted to place a light inside the monitor but was not able to. Instead, I used a light with a grid spot and a little warming gel over it to light the model's face. A second light was placed behind the monitor, but this one was aimed at the wall. It was flagged off in a V shape to look like the glow of the screen.

A main light to the left was covered with a heavy blue gel (actually two layers of gel). The

blue suggests nighttime. If I had let it go black instead of blue, there would have been no detail in the shadows. Another light, an unfiltered light bank, was placed to the right to get some neutral-colored light on the boxes. I was having trouble getting enough light on the boxes to produce the look I wanted. The boxes were just a hair too dark, and I thought they should be lighter to read better. Those boxes were a very important element for the client. They needed to pop more. So I added a spotlight, placing it in front of the light bank and pointing it into the center of the boxes. This opened up the boxes, and they read much better in the photo.

The background of moon and sky is a painted backdrop with a blue gelled light; another light, ungelled and with a grid spot, was aimed at the moon. Shake well, snap the shutter, and presto, there it is!

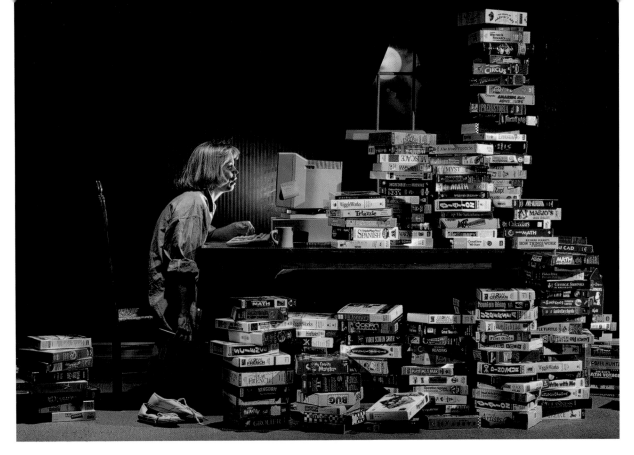

I did this shot for *Newsweek*, illustrating a parent checking out all the software available to her kids. Again I used that old combination of cold blue light and warm orange light to evoke a feeling of night-time at home. An unfiltered strobe head illuminated the boxes so they would stand out from the gelled scene, and another unfiltered light with a grid spot was used to light the moon. Several strategically placed detailing lights were used as well.

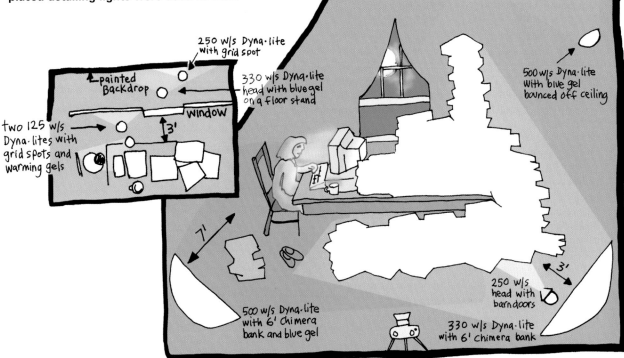

I think I used almost every light I owned to shoot this Coleman latern catalog cover. In order to get the lantern to "glow," I put a slight diffusion filter on my Mamiya 180mm lens and shot at about 1/4 second to get its light to register on film. Since the lantern was the star of the scene, it also needed to look like it was illuminating the sky. In fact, the scene was lit mainly by a large bank light to Santa's left. In front of the bank, a strobe head with a grid spot and warming filter was used to simulate the orange glow of the lantern onto Santa because the lantern alone did not glow brightly enough to illuminate him. For the background, I placed two Dyna-Lite heads on floor stands with blue gels over them and aimed them upward onto the blue seamless paper. We made the "stars" by punching holes of various sizes into the seamless. Behind the blue seamless is a white wall that had several strobe heads pointed at it as well as several heads pointed towards the camera to produce bright spots in the night sky.

In addition to shooting Polaroids to check the light balance, I'd also recommend shooting a test roll before the shoot so you can see what the lit set looks like on film. For instance, blue light looks very different on Polaroid than it does on film. I once did a shot with a blue gel in which I thought we would barely see the blue. Because of the deadline, I didn't get a chance to run a roll beforehand. I was almost as surprised as the client. I had *lots* of blue, buckets of blue, way too much blue! So, whenever possible, I try to shoot a roll of film with my basic lighting setup and variations, using my assistant or whoever is available as a stand-in. The clients love to see something on film when they walk in, not to mention that it makes me feel better to see how the lighting and gels look on film. If a variation doesn't work well, then I don't show that portion of the test to the client.

The shot of Santa Claus is also heavy with blue light, again illustrating how blue suggests nighttime. Without the heavy blue, this photo just wouldn't look the same. In the film industry they have a shot they call "day-for-night," where a daytime shooting is done with a heavy blue gel to simulate a night shot. You can always tell this shot because of the heavy shadows caused by the sun, but it still passes as nighttime.

In the photo of the granddad and grandchild, the shaft of light in the background has nothing to do with the light falling on the models. It is flagged off to appear to be the same light as the foreground. It takes two lights to create this illusion. Many times, I want to light the background and foreground with different lights, but I always want them to look like they're one light, from the same source.

This shot was done with a light bank on the right side, directed at the models. A 4 x 8-foot sheet of black foamcore kept the main light off the background. A second light was placed on the right side pointed at the background, and we were careful that none of that light fell on the subjects. I used two flags to form a V shape and placed them between the background light and the background. I like to keep the flags on separate stands, independent of each other. That way it's easier to make changes. If they are connected, I always want to move just one, then end up moving both by mistake, then having to readjust again because the second one's not where it was—and then I want to move the first one again. Arrggh! Believe me, experience says use two stands for accurate control...and to maintain sanity.

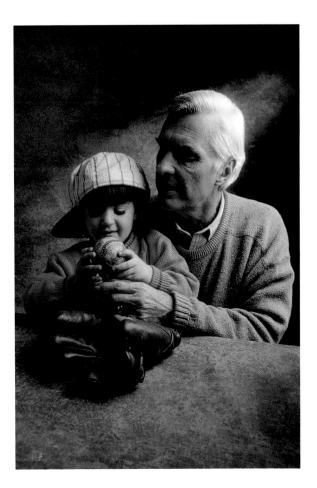

To get this intimate granddad and grandson shot I used two lights and a lot of flags and nets. The foreground and the two models were lit with a medium Chimera bank. I didn't use a bigger light bank for this shot because I wanted the shadows to be relatively dark.

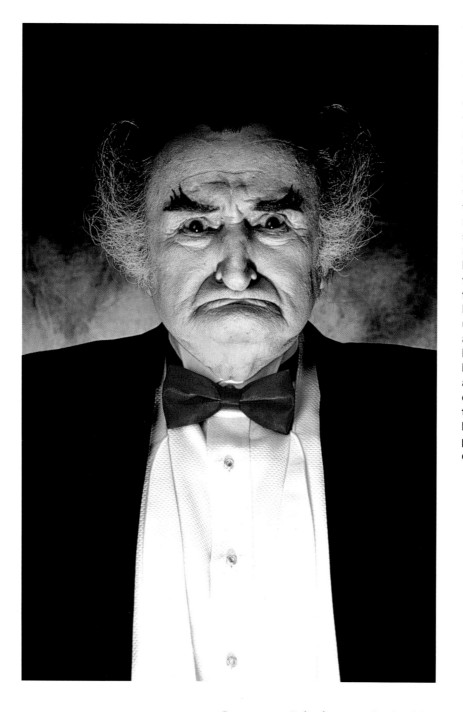

What fun it was to shoot Al Lewis. My client was selling a series of scary books for children and wanted him to model as his old TV character on *The Munsters*. To get this sinister lighting I set a Dyna-Lite head low to the ground and aimed it upward. I used a small black net to feather the light so it wasn't too hot near the bottom and a little detail was maintained in his white shirt. However, I was careful not to flag it off too much because I wanted to keep that sense of light coming from below. I used a second light behind him to lighten up the background and create some separation. Again, I didn't want it too bright, so I aimed it low. I lost the light at the top of his head, which caused it to blend in with the background, something I wouldn't do in a regular portrait, but for this scary effect, I think it's perfect.

Sometimes I don't want the backlight to look like it's the same as the front light, I just want to separate the subject from the background. At that point, I just make a subtle "halo" around the subject. When I shot "Grandpa" Al Lewis, the client wanted the background to be very dark. But without a background light, and with a dark jacket, Grandpa Al would have blended into the background. Better to put a little light behind—just enough to separate, but not enough to overpower.

Adding Some Energy

What you see here is an example of "dragging" a shutter, mixing tungsten light (3200° Kelvin) with strobe (5000° Kelvin). The strobe freezes the subject, while the long exposure lets the tungsten blur the edges. The longer the shutter speed, the more blur you get—but the strobe keeps most of the subject sharp.

You can also create a little subject blur by moving the camera, which will also blur the background. Or by keeping the camera stationary on a tripod and having the subject move, you will keep the background sharp.

When experimenting with flash it's important to remember that the shutter speed affects the tungsten light, not the strobe. Only the aperture affects the strobe exposure. So if the background is too dark, you can use a longer shutter speed and not affect the subject's exposure. Don't forget to experiment with major changes in shutter speed and with movement to see what different effects you can achieve. Sometimes just a small amount of movement is enough to create the mood you want. Sometimes it takes a lot of movement to make it look interesting.

Moving the camera to the right creates a different effect than moving it to the left. That's because one way you're forcing the subject's impression into the light's space. When you reverse the movement, you force the light's impression onto the subject. One way makes the highlights bleed into the shadows; the other gives the highlights an "outlined" effect. I know it sounds confusing, but if you try it, you'll be able to see the difference. One looks slightly more extreme than the other. Both are ways by which you can introduce a little energy into a static subject.

A lot of shooters drag their shutters when photographing very stiff subjects, such as corporate executives. Just throw a tungsten light on the background and light the executive with a strobe. Moving the camera adds a little motion and excitement to the picture.

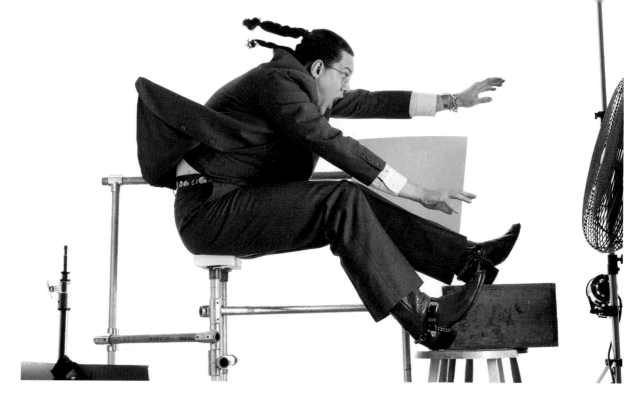

Rigging is the term used to describe the means of securing something into a fixed position or making a person or object appear to be doing something that couldn't normally be done. Unfortunately Penn Jillette, of Penn and Teller, doesn't normally fly through the air. So I had to make him look as if he were actually leaping over something. Rather than try to catch him in mid-hurdle, I built a supporting rig out of Speed Rail, the metal posts and couplings that are visible underneath and behind him. As long as the rigging is behind his silhouette, they can be easily removed from the image. Never construct the rigging so that it crosses in front of the subject's silhouette, because that requires complicated retouching.

Rigging

Illustration photography requires that you control every aspect of the image. I exercise control through lighting, propping, and casting, but sometimes control has to go beyond the laws of nature. Sometimes I need papers to float gently in the breeze; or a model, who's not particularly athletic, to jump gracefully through a hoop; or a client's product to be clearly seen in a hyperactive four-year-old's hands. How do I make everything in my photographic world behave according to my wishes? With rigging.

Rigging is the magic, the sleight of hand of photography, and I do a lot of it. I feel like the Wizard of Oz, standing behind a curtain, pulling all the switches and levers to make the magic happen. Of course, making magic really means using common sense to solve problems.

Rigging can be bone simple, like holding a doll in place for a four-year-old model, or it can be complicated, like making an adult seem to fly through the air. In all cases, it has to be believable...and invisible.

I used to hire special-effects people to do my rigging, but then I realized that I had a knack for it, and I truly enjoyed it, so now I do most of it myself. I say "most" because if it looks like it might be dangerous, I hire the pros.

My favorite tools for rigging are armature wire, Speed Rail, hot-glue guns, tape, monofilament (fishing line), sheet rock screws, sticky putty, staples—and anything else that works. Armature wire is strong, flexible aluminum wire, which can be purchased in gauges from very thin to extremely thick. Sculptors use it to build the underlying skeleton, or armature, of their sculptures—so it can be found in the better artist supply stores. It can also be found in photo stores that cater to the professional.

I use armature wire to float objects and to hold them in place. In order to do either, I first have to connect the prop to the wire, and for that I use gaffer's tape, the cloth version of duct tape. Gaffer's tape has better adhesion than duct tape. It's a lot more expensive, but well worth it. (Give me a few rolls of gaffer's tape and I can fix the world.) Sometimes, though, I come across a plastic toy that gaffer's tape won't stick to, so I use hot glue to secure the toy to the armature wire. Generally, when I use hot glue in rigging, I need it to set instantly, so I take a can of canned air, hold it upside down, and fire a blast over the hot glue. The propellant, which is very cold, comes out with the air and essentially freezes the hot glue instantly. I just have to be careful not to burn myself on the hot glue or freeze my fingers with the canned air.

When hot glue isn't strong enough to secure a prop, it's time for sheet rock screws. In those cases I just have to be sure that the product I'm working with is not a prototype. Rigging can prove to be destructive, and a prototype of a $10 toy can be worth $10,000 or more.

When photographing some of the younger children and a toy with wheels, I'll screw the back wheels to the floor to keep the toy in place. Any screw will work, but sheet rock screws are thin, work fast in a screw gun, and have threads that grip well.

This shot for an annual report was a case of doing something with the toy that looked plausible, but could not happen in real life. No matter how nicely we asked, Mr. Potato Head would just not stand on this kid's shoulder. If the boy had been a stone statue, I could have easily puttied it or hot-glued it to him. But parents don't like it when I hot-glue things to their kids. By rigging the toy with my faithful armature wire, I was able to secure a tipsy Mr. Potato Head in place and concentrate on working with this great model.

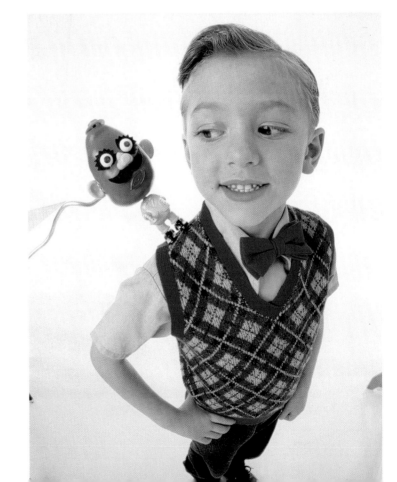

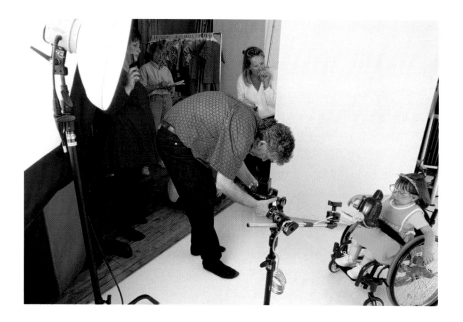

Over the past few years I've had the privilege of shooting the Toys "R" Us Special Needs catalogs. Having a child hold a toy up in a particular place for a period of time is difficult for most kids and nearly impossible for kids with physical afflictions. So I set them up for success by rigging the toy to a piece of armature wire. Because the toy is in a fixed position, I can concentrate on getting those great expressions from the kids.

Whenever I have to do a rigging shot, the first thing I try to decide is, what is the easiest way to do it? It's very important to follow the "KISS" principle, Keep It Strictly Simple. When I first saw this layout, I immediately thought of using a gymnastic training belt, and my stylist found one at a sporting goods store. To support the model, I took two 2 x 4 pieces of 8-foot long lumber and bolted them together to give me a 4 x 4 piece of wood. The wood was then screwed into special brackets that attached to the top of highboy stands, which normally hold 300+ pound lights. I tried it out myself before the model tried it, figuring that if it supported me, it would easily hold him.

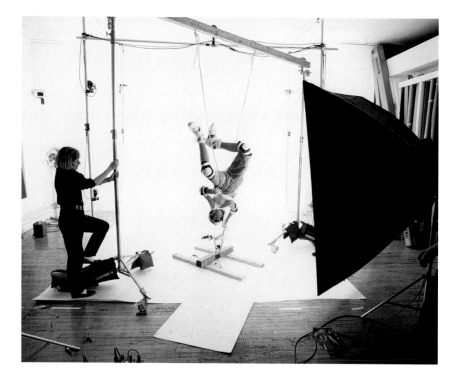

In this case we needed two large dolls to stay in place while the model stood between them. The simplest solution was to use L-brackets and armature wire. I used gaffer's tape to hold the dolls in place. Without rigging, these dolls would have been flying all over the set, because the model really wanted to play with them. Believe it or not, playing with dolls is much more important than having your picture taken when you're four years old.

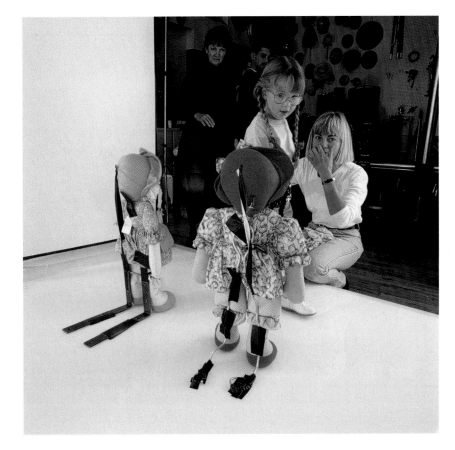

I also secure objects to the floor using various size L-brackets and sheet rock screws, and I'll use the same brackets with gaffer tape to keep objects upright, like a book on a table or a pile of diaper packages. Luckily, I have an old wooden floor in my studio, which now has a number of little and not-so-little screw holes in it. If you don't have a wooden floor, or if you have a floor you don't want to ruin, you can put down a plywood floor over the real thing before shooting. For a rig to work properly and safely, it's often vitally important to be able to fasten items securely to the floor.

To adequately support objects that are too big or too heavy to be safely supported with armature wire, I use Speed Rail, one-inch aluminum or steel piping with connectors, which are used for railings in factories and as fixtures in clothing stores. Set up properly, the pipes can easily support any person. Using Speed Rail to work out solutions to problems takes a Rube Goldberg-type thought process.

One of the best uses of rigging is to hold objects in place that otherwise would tend to roam, for instance, the shot of all the kids sitting next to each other holding books. It's the type of setup that, if not planned properly, is a pure nightmare.

When the client first gave me a rough sketch of this photo, I knew that we would have to use rigging. Five-year-olds all sitting close together and holding their books at the same height? Not in this lifetime. So I rigged each book with armature wire and attached the wire to a piece of 1 x 8-foot board, adjusting the wire so that the books all lined up at the top. All the kids had to do was sit down and put their hands on the sides of the books. There was a lot of movement to control, but at least we were in the ballpark and got the shot.

My client wanted to have five books, all lined up at the top, held in place by five five-year-olds. Getting this shot with only two kids would be known in the trade as "in your dreams"; with five, nearly impossible. I realized early on that the books would have to be rigged in place—that way the kids could just come in, sit behind the books, and place their hands in position. It turned out that even with the rigging, it was hard to keep everything and everyone in place; without the rigging, it would have been impossible.

I also used a simple rigging for the shot of the three- and four-year-olds shooting baskets like Michael Jordan. Kids that age are not well coordinated; "graceful" is not the proper adjective to describe their jumps. Add shooting a basketball to the task of jumping, and I'd be in "forget about it" territory. But by taking away one task by screwing the basketball to the backboard, the tikes can look like NBA All-Stars. I just asked them to jump up and touch the ball. I missed a lot of shots—like eight or nine on a ten-exposure roll—but oh, when I hit, I hit big.

Over the years I've done several "throwing papers into the air" shots, and each time the clients thought I'd just throw the papers into the air and snap the shutter. In fact, one of the shots was made to duplicate a TV commercial, and that's exactly what they did—

they went to the second story of a building and threw out lots of paper. But still photography is not like film or video. I don't have the luxury of recording movement, which can hide a multitude of sins. In still photography I freeze the moment, and later the viewer can stare at every flaw. Everything has to look perfect for the still camera, and throwing a bunch of papers in front of the lens is a recipe for disaster.

With the magic of rigging, we were able to produce a photo of this up-and-coming NBA star, Eliazar Smith, at four years old. In reality, four-year-olds and coordination are not exactly compatible. We'd have been there a long time waiting for him to make a basket, and we had only one hour to get the shot. If you compare the "casual" shot with the "hero" shot, you'll notice the basketball hasn't moved. Coincidence? I don't think so. The ball is rigged from behind. All little Eli had to do was jump up and touch the ball.

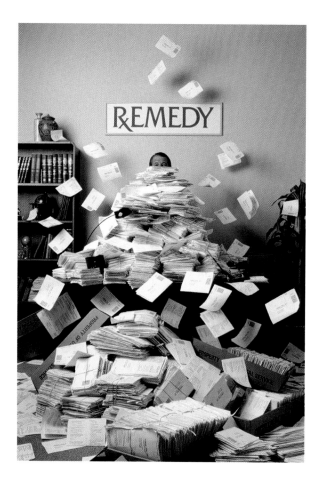

Whenever I have to shoot something like papers flying in the air, I have to decide if I should actually throw the papers and shoot it, or rig the papers in place. While throwing papers would be "real," you have no control whatsoever. The trick is to make the rigging look real. When building this type of set, I set a camera up in place, and we build "to camera" (from the camera's viewpoint). To get the papers to look like they are actually flying, I attach each piece of paper to a slightly smaller piece of stiff board with one or two corners cut off so I can curl the paper to simulate its movement.

If papers were going to fly, the control freak part of me needed to be in charge of every piece. (After all, the client didn't want any of the papers falling into the area of the frame that was needed for his copy.) It was no problem, I just taped each piece of paper (supported by cardboard) to a one-foot length of armature wire; then, with a staple gun and large staples, I fixed the other end of the armature wire to the exact spot on the wall where I wanted it.

In this way, I placed every piece of paper carefully on the set—and added a bent corner or two to each piece to give the appearance that the papers were floating through the air. Paper can also be placed at an angle—paper doesn't fall in perfect verticals. The trick is always to set up everything with the camera in place so you build to the camera's point of

view. As long as the support is behind the object you're photographing, it may as well not exist. Armature wire? What armature wire?

If you need to rig something heavier than armature wire can hold, it's no problem, as long as you can get your support through the set wall and secure it. You can even float a computer; all you need to figure out is how to attach a support, most likely a 2 x 4, to the computer and then brace and balance that 2 x 4 behind the computer so that the camera doesn't see it.

A fun project that went beyond reality involved a set of Toys "R" Us and Kids "R" Us posters for which I photographed cornucopian bags of toys and clothes, overflowing with product. When I first got this assignment, I knew it was going to be a fun rigging job. Each setup would be its own sculpture. Of course, the trick was to do ten of these in three days!

Shooting these bags o' toys for Toys "R" Us involved building a tower of toys and rigging it all together so that all the model had to do was place his arms around the bag. I started with a shell of the bag, and slowly added to the pole sticking up through it. Our first consideration was to place the toy where it looked good, and then we figured out how to rig it in place. Some toys were taped to another toy already secured. Sometimes a piece of armature wire or pipe was used. Sometimes fishing line was required to pull something so it sat at the proper place. Hot glue was also very helpful.

It took the stylist a full day to gather the toys and three of us about three to four hours to build one of these towers, about a half-hour to prep the model, and about a half-hour to shoot the picture.

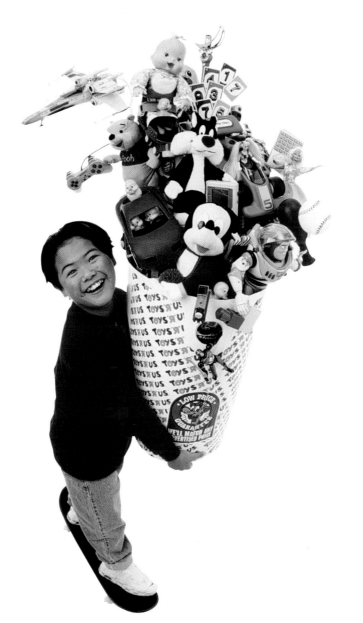

Each setup was done so all the bags of toys and clothes would be stationary, floating in the air by themselves. Then all I'd have to do is bring a child on set and have him put his arms around the floating bag. Everything would be shot in silhouette against a white background; the illustrated backgrounds would be added later. This made the rigging a lot easier—I didn't have to hide it. As long as the rigging was behind the subject, it would be silhouetted out. I just had to maintain a clean silhouette; nothing could cross in front of the subject.

Some photographers might ask, "Why not just shoot each toy separately or in groups and assemble everything in a computer?" Because I think those kind of shots look horrible. In fact, months after these shots came out, a rival department store chain put out a similar-type ad and used a computer to assemble it. It looked terrible (I believe the technical term is "butt ugly"). Because the items were pieced together haphazardly, the perspectives didn't match, and nothing looked real. Putting elements together in a computer may be physically easy, but making it look good is the real trick. Too much computer manipulation can make an image look false.

The image of toys jumping out of bags was further enhanced by the use of a fisheye lens—a 37mm on my RZ67 (the equivalent of an 18mm fisheye on a 35mm camera). I didn't want the final image to look fisheye distorted; the lens was used just for its "exploding out of the bag" optical effect.

I also tried to match toys in each shot to the backgrounds that were going to be added later. For example, the Empire State Building was going to be in the background for one of the kids, so I put King Kong and some planes in the bag.

All the toy rigs were hot-glued, gaffer-taped, fishing-lined, or bubble-gummed together...whatever worked. As you can see from the rear-view photo, the back of these rigs is just a jumble of support. Note how the armature wires are attached to the toys and then attached to the Speed Rail support.

When similar shots were done with clothing, the clothes were stacked on rigged ledges so I could insert or take out bunches of clothes. If the art director decided that the grouping had too much red, I could just take out that ledge's layer and put in another color.

The agency working on the KODAK Copiers account wanted to shoot three ads with three salespeople: one standing on his head, one bending over backwards, one jumping through a hoop.

Rather than using a smooth-textured seamless background, I shot all the pictures against a carpet, which kept the background

The rig is just a 2 x 4 standing vertically with another bracing it from behind. Both pieces of wood are screwed down to the floor, and two pieces of Speed Rail support the brace. They too are screwed into the wooden floor under the carpet. If you look closely at the second photo, you can see the outline of the pad that we put under the carpet to cushion the model's head.

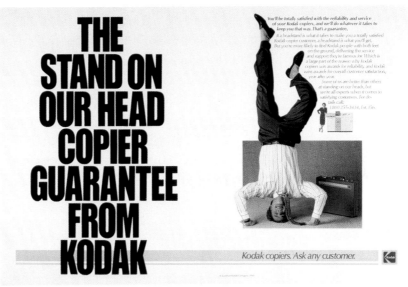

clean while giving it texture. I started with the two simpler shots—headstanding and bending over backwards. I knew they'd be easier, so I allowed one day for both. I scheduled the hoop shot for the second day of shooting; in case we ran into problems, I'd have all day to get the shot. As it turned out, all three went smoothly.

Standing on one's head seems easy enough, but for the length of time we needed the model to maintain the position, we needed to give him a little help. I built a simple triangular rig of 2 x 4s and screwed them into the floor so the model would have something to lean against. Doing a headstand with no support is a lot harder than doing a headstand leaning against a solid support. I also placed a piece of foam under the carpet where the model's head would be to make him a little more comfortable. An uncomfortable model would have a much harder time giving me the natural, happy expression I needed for the shot. Still, he told me later that he had a headache for two days following the shoot. As you can see, by placing the rigging directly behind him, it is invisible to both the camera and viewer.

Studio Essentials

What's the most important piece of non-photographic equipment a photographer can have? Ask a group of shooters and you'll get some interesting responses: orange traffic cones, gaffer's tape, and Swiss Army tools that include everything but refrigerators. My friend Gary Gladstone uses walkie-talkies all the time, not just for communicating, but also for the power they seem to give the people holding them. He's been in many situations where just having a walkie-talkie has given him enough authority to operate without interference from curious bystanders.

For me, the holy trinity of helpers consists of armature wire, Speed Rail, and gaffer's tape. Armature wire helps me rig things quickly—things I didn't know I needed to rig, like a child holding a doll. (Ever try to get a three-year-old child to hold a doll in place? I have, many times. If it's a silhouette shot, no problem, I just support the doll with armature wire.) Speed Rail is perfect for rigging stuff that's too heavy to be held by armature wire. And finally, gaffer's tape—the photographer's best friend. Photographers always need a good piece of tape to hold something together, to keep something small in place, or to keep something big from moving. I've gaffer-taped a lot of toys into position. Without the tape, the toy (the subject of the shoot) would be flying all over the place. (Again, it's gaffer's tape, not duct tape— duct tape doesn't have the holding power, it is harder to handle, and the glue comes off the backing, which creates all sorts of problems.)

Speed Rail is sort of an adult erector set and for jobs like this, it is ideal. The Speed Rail system has various angles, joints, and end pieces that hold the pipes together. The skis were bolted to 2 x 4s, which were supported by poles from underneath. We made a small pipe "seat" to help the kids crouch in the proper position and a pipe running diagonally across the set, acting as a support for the kids to grab if they started to lose their balance. An assistant was spotting just outside the frame. The giant pencils are hot glued to thick-gauge armature wire. The white cards behind the pencil points and skis make it easier for the retoucher to silhouette the pencils. I always try to be as cautious as possible, planning for any contingency.

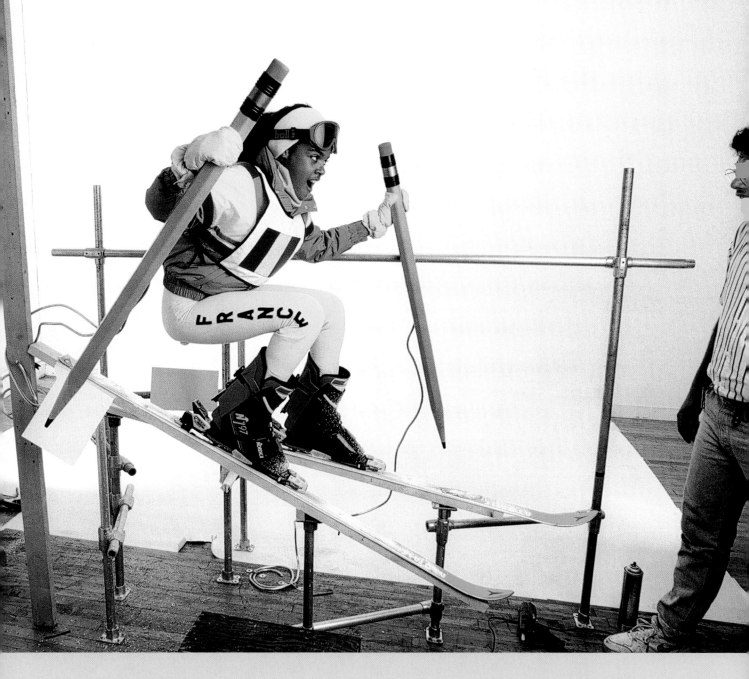

A lot of great photo equipment can be found in non-photo stores. Tell any photographer about an especially well-equipped hardware store, and watch their eyes light up! Every photographer I know experiences an increased heart rate the moment they walk into a truly great hardware store. For all the expensive equipment I own, nothing is as satisfying as improvising to find a solution to a problem, often with an inexpensive home remedy and an inventive helper.

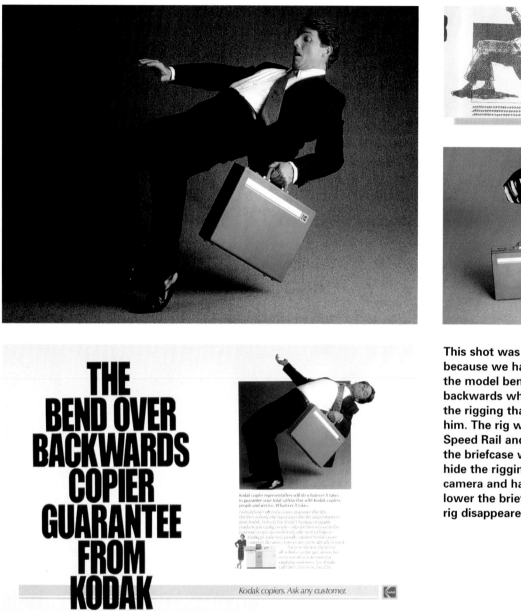

This shot was tricky because we had to shoot the model bending over backwards while also hiding the rigging that supported him. The rig was made of Speed Rail and a 2 x 4, and the briefcase was used to hide the rigging. I raised my camera and had the model lower the briefcase until the rig disappeared behind it.

I thought the second shot—a guy leaning over backwards—would be easy and not involve any rigging, but as I started to shoot, I realized that the photo did not read as bending over backwards. Instead it looked like an aerobic exercise gone wrong. So I built a quick rig to support the model at the small of his back—just a 2 x 4 screwed into two Speed Rails, which were then screwed into the studio floor through the carpet. I shot from a high angle and used a long piece of wood to support his back, making the rig fall behind the briefcase and disappear. Best of all, the model ended up looking like he was really bending over backwards.

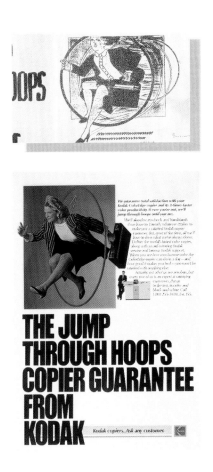

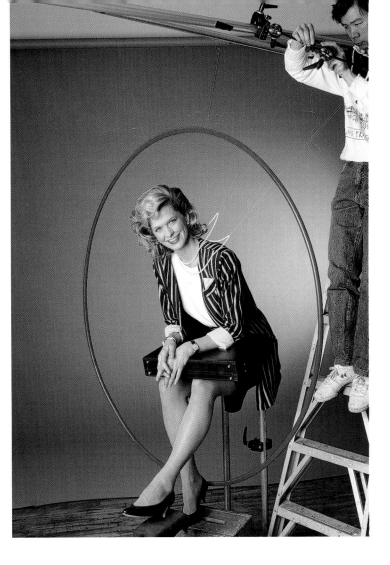

The last shot of the woman jumping through the hoop was the hardest. It had to look natural. The art director initially thought we would have the model just jump through a hoop, but my fear was that it wouldn't look powerful or correct enough on film. Also, unless I got a real high-hurdle jumper and expanded the length of my studio for her to get up to speed, jump, and then decelerate, it wasn't going to happen. After giving it a lot of thought, I concluded that rigging her in a frozen leap would look more real than if she just jumped through the hoop. So out came the Speed Rail, and I mounted two lengths vertically on the floor and attached a little padded 2 x 4 x 8" seat. There's also a second, small rig that supports her leading leg. She sat there for 45 minutes while I fine-tuned the shot. Since this shot was going to be retouched, we ended up shooting the woman and the hoops separately, to give the art director the most flexibility in terms of size and placement. Actually, the biggest problem was finding hoops big enough. We called everywhere, and finally someone at a circus told us to try cutting and putting two hula hoops together. It worked. Then we spray-painted the hoops in primary colors. We had to handle them gingerly as the paint didn't stick well to the plastic. At least it stayed on long enough to get the shot. To photographers, that's all that matters.

As you can see, I used Speed Rails screwed into the floor through the carpet and a small, foam-covered 2 x 4 as the model's seat. I used a fan to blow her hair, monofilament to hold back her necklace, and a little gaffer's tape to hold back the flap of her jacket. Of course, the designer had to retouch the image to remove the rigging in the final ad.

CHAPTER 5

EQUIPMENT AND FILM

Equipment

I'm a believer in having a basic camera system and not buying every new gee-gaw that comes down the pike. The best camera? It's the one that feels right in my hands, has controls that make sense to me, and has features that I'll really use. I don't care that a camera can jump into the air, whistle a pre-programmed song, do a half gainer, and land back in my hands. I can't remember the last time I needed a camera that whistled. ■ There are, of course, features that I do need—like a Polaroid back. To me that's a "must have." Also, interchangeable backs for medium format. Access to quick service and repair is very important, too. Going through as much film as I do, I have my cameras and lenses on a regular maintenance schedule; simple wear and tear take their toll. ■ Keeping in mind that what works for one photographer may not work for another, here's the gear I use. ■ My workhorse camera is a Mamiya RZ67 that handles 90 percent of my studio shooting and about 75 percent of my location work. I shoot almost all of my shots of children on the Mamiya.

Most of the time I want to minimize distortion, but sometimes it's fun to force perspective to the extreme by using a fisheye lens. When shooting products and people with a fisheye, there always seems to be one point of view, one sweet spot, where the product looks good and the model doesn't look distorted. Moving just a few inches from that spot will overly distort the product or the model. In this shot I placed the little girl in the center of the lens, which distorted her face very little but did stretch the shape of the oven and the tablecloth.

Yeah, I've had a lot of great shots on the eleventh frame...too bad 6 x 7 gives you only ten. But I love the quality of the 6 x 7 chrome. For 35mm, I use Canon equipment, and for those rare occasions when I have to use 4 x 5, I have a Toyo view camera.

My primary lens for the RZ67 is a 100-200mm zoom (the equivalent of a 50-100mm on a 35mm camera). I own a wide-angle (65mm), a normal (110mm), and a telephoto (180mm) as well. I'd originally bought the zoom as a backup for the normal and the tele, but after I saw the zoom's results, I became convinced that a zoom could be as sharp as a prime lens, and so the zoom is now my main lens. The convenience of zooming to crop and recompose on the fly makes it my first lens of choice. I also own a 37mm fisheye lens, which I bought after I'd rented it for the third time. I don't like to rent equipment too often. My feeling is that if I have to rent it three times a year, I should own it. That way I know what I'm using and what condition it's in.

That's not to say I don't think renting is a great way to keep control of overhead. Why would I spend $3,000 on a new lens that I might use twice a year when I can rent it for $250 to $350 a year? Renting, in that case, makes better business sense. Right now I seem to rent a 250mm Apo RZ lens about twice a year. I'm waiting for that really big assignment when I'll need it for a third time in a year. Then look out.

Leasing camera equipment is a good way to deal with the ever-changing, expensive equipment dilemma, and now that new systems can cost as much as a car, leasing camera equipment is becoming as popular as car leasing. At the end of the lease—usually about three years—you can buy the equipment for a nominal price. Several shooters I know do this and then sell the equipment on the used market and upgrade with a new lease on new equipment. If business is going well, and you're using your equipment a lot, this isn't a bad way to go.

When I do need to purchase expensive camera equipment and studio gear, I tend to make my purchases during the last quarter of the year. At that point I've monitored the year with my accountant and I have a good feel for how much I can or should spend on the business before the year ends.

One of the things you need to consider before shooting is what kind of feel you want the final image to have: a warm and fuzzy, cooler, hotter, or even a muted soft look. All of these effects can be enhanced with a combination of filters, lighting, and careful choice of film. For close-up skin shots like this one done in the studio, a slight warming filter either on the lens or on the lights gives the skin a nice warm glow.

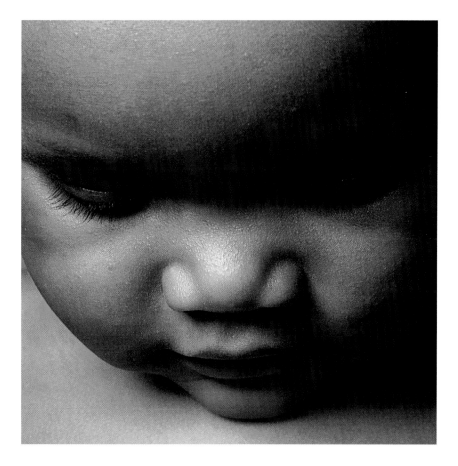

Film

Right now the film I use most is KODAK EKTACHROME 100 Plus Professional Film. The main reason—other than great color—is that it reproduces better than any other film I've used in studio situations. Most separators seem to know the EKTACHROME family of films and how to separate it for printing. When choosing a film, keep in mind the end result: If magazine ads are the goal, then use the film that gives the best reproduction on the printed page.

A film I'm currently looking at is KODAK PROFESSIONAL EKTACHROME Film E100S, which seems to feature greater resolution than EKTACHROME 100 Plus Professional Film. The only reason I'm waiting to change to EKTACHROME Film E100S is that I want to be sure that the new emulsion is as stable as EKTACHROME 100 Plus Professional Film. From what other shooters have told me, it is stable, but like many photographers, I'm slow to change.

I test every new emulsion before using it for a job. Years ago emulsions could vary by as much as 10CC of color, with 05CC being about the norm. These days emulsions seem to vary only about 02CC at most, but I still run tests because I can't take a chance and find out too late that the balance is off. The film might be too magenta, too green, too fast, too slow. Just because they say it's EI 100 doesn't mean it isn't really EI 81 or 124. One must also consider how the lab is running. If you have a film that's a little fast and a lab that's a little fast, put them together and it spells disaster. It's up to you to determine how a film works with your system.

I like to have my film in sync with my Polaroids, and the quickest way for me to test my film is to do a quick setup to determine how the film relates to the Polaroid, and how it treats skin tones, shadows, and grays.

I have a simple, one-light method for determining all this. I place a model six feet in front of a white wall. To the right of the model I place a large white card, usually a 4 x 8-foot piece of foamcore. The foamcore is placed at a slight angle so the left side of the board's edge is behind the model, bisecting her. It should be close enough to the model that she casts a shadow on the foamcore. Where there isn't a shadow on the foamcore, it should be bright white. The far wall should be visible behind the other side of the model and should read as gray. If it's reading white, then you're either too close to the wall (in which case you need to move the model and foamcore away from the wall) or it means that your main light is spilling too much onto the back wall. You can block the main light somewhat or reangle the light. This gives me a test that offers a skin tone (the model's), a clean

white surface (the foamcore), a clean shadow (the model's on the foamcore), a good, neutral gray (the far, white wall), and color (whatever the model is wearing or holding). This test will quickly tell me a lot about a film. I also like it because I can perform it under consistent conditions in my studio. It wouldn't do any good for me to shoot just anything anytime I needed a test. I need a consistent benchmark.

I perform this test when I first get an emulsion in order to understand what the emulsion looks like. After I find an emulsion I like, I'll try to do a test on the set where I'm going to shoot, with the lighting I plan to shoot with.

This is my typical setup for testing film. A film test is an essential tool for evaluating a film emulsion. Just because a film is rated at EI 100 doesn't mean it is not really EI 81 or 124.

TAKE NOTES

Testing and knowing film isn't enough, though. When I shoot I take notes, and pity the poor assistant who messes up my film notes. It's the one thing that students barely look at during my workshops, but out in the real world of professional photography, they're going to realize that their film notes are as valuable as their lenses. Good film notes tell the story of a shoot; notes taken on a test roll tell how to run the film. As you can see from the film note page shown on the next page, I log a lot of information on each job.

Film notes are the "story" of a shoot. These notes are well worth the effort as most photographers do not have photographic memories.

Data Sheet 1

Job #: 1782 Date: 2/27 Client: TRU Product: Annual Report
Film/Emulsion: 2731 EPP Pol. Total: IHT II Assist: Norman Smith
AD: Liza Pryor Stylist: Sandy Smander-Props H&M: Debra Engelsman
Joyce Whalen - On Set

Test Frame	Roll	1st Run	2nd Run	Exp	Description and Changes	Attach Polaroid
1-D 1,2	1	N		16½	Tonka Truck /	
	2		N		Michael	
	3	N				
	4		N			
3,4	5	N		22	No Hat	
	6		+¼			
5,6	7	N		16½	Ninja Turtles /	
	8		N		Zachary	
	9	N				
7,8	10		N			
9,10	11	N		16½	Easy Bake /	
	12		N		Shawnice	
T-2 1,2	13	N			▲ left back light	
	14		+¼			
3,4	15		+¼			
5,6	16	N		16¾	Cabbage Patch /	
	17		N		Colleen	
7	18	N				
8,9	19	N		16¾	Mr. Potato Head /	
	20		N		Quin	
	21	N				
10	22		N		▲ on Shoulder	
	23	N				
T-3 1,2	24	N			Lego / Marcus	
	25		N			

The first field at the top is for the job number—your *studio's* job number, not the client's. Next, the date of the shoot. On multi-day shoots, I list each day. Next is the client's name, i.e., the advertising agency or magazine. Then comes the product name, if there is one, or the project name, if there isn't a product. In the case of an editorial shoot, I put the story name under the product heading.

On the second line I note the film type and the emulsion number. In case of the rare re-shoot, I try and match the emulsion if I still have some. If I'm shooting a brochure or catalogue in which there are many shots—and because of product changes, many re-shoots—this helps keep the film consistent for the separator. Next on that line is my Polaroid count (Pol. Total). My assistant enters a vertical line for every pack of Polaroid used, and a diagonal for every fifth pack, so I'll know how much I used and how much to bill the client. Next is the name of my assistant for the job so I'll know who to yell at if I can't read the notes.

On the third line I write the art director's name. This is important in case it's a large client, like Toys "R" Us or Reader's Digest, for whom I do many jobs during the year and therefore work with several different art directors. I need to know which art director worked on which project. Next I list the stylist and the hair and makeup (H & M) people working that job. These two fields were recently

added after I had a job in which I needed to know who the crew was, and we had to use other records to figure it out. It took us a while.

If the shoot requires a complicated lighting setup, I have my assistant diagram the lights on the back of the sheet and perhaps attach a Polaroid of the setup.

Of course, all this information, with the exception of the Polaroid count, is rarely referred to. But, boy, when I just have to have it, it's a lifesaver to be able to go back to the job file and research or recreate a shoot.

Under all that header information, you can see I have space on the page for entering data on 25 rolls (or sheets of film). I also have pre-printed pages numbered from 26 to 50, 51 to 75, and 76 to 100. After we reach 100 rolls—which happens several times a year—my assistants just write in a number before the pre-printed roll number to make the sequence of roll numbers consecutive (e.g., 1 can become 101, 23 can become 423, etc.).

For each roll there are seven columns. The first is for the test roll and test frame numbers. This field tells me which test frames on each test roll correspond with which rolls of shot film. I call the first test roll T-1, and if I shoot two test frames, I jot down T-1 (1, 2) in the field. These test frames correspond to rolls 1, 2, and 3. In the fifth box (across from roll number 5) it might read T-1 3, 4, showing that I took two test frames before shooting roll 5. So by reading my notes, I know that frames 3 and 4 on the T-1 test roll correspond to shot rolls 5 and 6. This goes on until I finish the T-1 test roll, after which I start test roll T-2, then T-3. I've taken as many as a dozen or more test rolls on a job.

The main sunlight in this shot was provided by a battery-operated Dyna-Lite strobe with a warming gel. I also used a warming filter on the lens. In addition, I underexposed slightly so I could push the film a 1/2 stop at the lab to boost the contrast slightly and add a little brightness. While I don't mind pushing (overdeveloping) film slightly, I rarely pull (underdevelop) the film to make it darker. Pulling the film processing flattens the contrast and the colors slightly.

Let me explain about test shots. For each new setup I shoot a couple of test frames to give me a visual reference as to how the shot looks on film and to let me make decisions about how I want the film run. On every medium-format shoot I have a film back, or in the case of 35mm, a camera body, that has the word "Test" written on it. I use that back or camera to shoot test rolls (consecutively numbered T-1, T-2, and so on) throughout the shoot. As each test roll is finished, I send it out to the lab ASAP. On an all-day shoot I try to get the first test roll out before lunch, so I can see the results by 1:30 or 2:00 PM. When those test rolls come back to the studio, I decide how I want to process the "real" rolls. If the test frames are a little darker than I want, I can push the film at the lab a quarter or a half stop, or if they're very dark, I can push it a whole stop or more. If the test frames are too light, I can pull the processing to darken the film. (I can push a lot more than I can pull; pulling can muddy up the film and cause severe color shifts.)

Why do I go through this rigmarole with the film? When photographing people, especially kids, I never, ever bracket. There's a cruel law that states that if you bracket you'll find the perfect shot taken at the wrong exposure. Always. And another is if you do a clip test—you send in a roll and have the lab "clip" a piece of film so you can see what your exposure is—you can be sure that the frame they cut into will show just enough for you to tell that it was the best frame in the whole shoot.

I don't like to lose any frames. With babies, you sometimes get only one good frame, and it's impossible to do it again. That's why I do test rolls. If it's a tricky subject and I don't think I'll get a lot of film during the shoot on set, I'll use a doll or an assistant as a stand-in if the skin tones are close, and I'll shoot that for my test rolls. I've run test rolls with just one exposure on them. It's worth it to waste a whole roll just to get the information from that one frame of film.

Each field in the next column is preprinted with a roll number. My assistant writes that roll number on a round, one-inch label and places it on the film back or camera body. I insist on this. First, so I can see what roll number I'm on, but more important, so my assistant can keep track of which roll is which. I've found from my assisting days that if this isn't done, eventually the assistant has two film backs and not a clue as to which roll of film is which number. This all sounds simplistic, and most of the time it's not necessary, but believe me, when I have a problem, having this information can be crucial to saving the shoot.

On jobs when I'm shooting 120 film, my assistant puts the sticker with the film roll number on the end of the roll, so it can be read as the film stands up in our "egg-crate" box. An assistant I worked with years ago (who today is a great photographer) took a brick of 120 film, taped the cartons together, opened them, and removed the film. That created an "egg crate" that could hold 20 rolls of exposed film. Today I use several on every shoot, and with the exposed film in the crate, I can easily read the film roll numbers.

I always try and take a test roll before an actual shoot, having my assistants stand in for the models. Even if things aren't perfect, it gives me an idea of what will be on the film, what the lighting looks like, how the film is reacting, if the emulsion is fast or slow, if it needs more filtration, if it would look better overexposed, if I have enough props, how the props read on film, and so on.

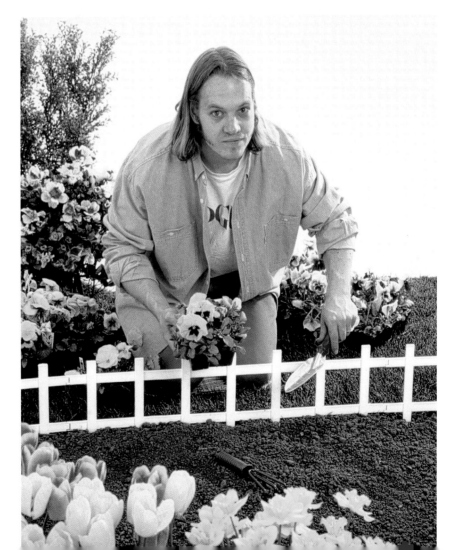

The next two columns on the data sheet read "1st Run" and "2nd Run." This indicates the batch of film that has been sent to the lab. I never send all the film to the lab at once. I split all the exposed film into at least two runs. Sometimes I choose every other roll (even- and odd-numbered rolls), and sometimes I just split the film randomly into two halves. This practice has saved me three times in my career. What a lifesaver it was to have undeveloped film from the shoot in my hands as the lab was telling me that they had ruined all the film in the processing run. For this reason, if I know I'm not going to shoot a lot, I try and get images on two different rolls. Even with bracketed still-life shots, I'll shoot two rolls and maybe not even process the second one. I just have it as a safety roll. In the 1st or 2nd Run box I put the speed at which the film is being run at the lab. I write "N" for normal, "+1/4" for a quarter-stop push, "−1/4" for a quarter-stop pull, and so on.

If the client is in such a rush that I don't have time to split the runs, I tell him I'm going to hold back a few rolls of film, say one roll from each setup or situation. That way, if I shot six rolls, I'll send five in for the first run after I've seen the test (that's a must, under any circumstances)—and hold the sixth. I'll run the sixth later and send it on to the client; I just want to be safe and not have all my film at the lab at once.

The next column ("Exp") is for entering exposure settings (shutter speed and/or aperture). I mark it at the beginning of each shooting situation and mark it again only if I changed exposure during that situation or when I start a new one. This way I know exactly on which roll I changed my exposure. Any change in exposure during the shoot is also shot on the test roll as a visual reference and marked on the data sheet. (If I changed the exposure, I want to see the result before I run my film.) The film notes let me know exactly on which roll I changed exposures.

The next column reads "Description and Changes." This field lists the models' names and any changes that were made—model changes, wardrobe change, lighting, or anything I want to keep track of during the shoot. If it's a situation in which I'll shoot more than one baby on the same setup, I want to know which rolls are of which baby and how much film I've shot of each. It's not unusual for me to call out to my assistant during a shoot and ask how much film I've shot on a child. If he says "one" when I think I'm going to hear "three," I know I'm in for a long day.

The last column reads "Attach Polaroid," and it means just that: This is the place where a Polaroid can be attached to the sheet so when I look at my film notes, I have a visual reference. The Polaroids are cut to fit and taped to the data sheet. It's also helpful at the end of the day to look at the Polaroids and see what we did. It's usually a very nice feeling. This is also very helpful when I'm trying to locate a particular model who I remember was good, but whose name I can't recall.

All the paperwork on a particular shoot—notes, bills, Polaroids, lighting diagrams, *everything*—is placed in a manila file folder. I can find a particular prop source or tell you where I bought a blouse for a job I did last month, last year, or ten years ago in a matter of minutes (OK, maybe a half hour). This information can be important later on.

The job folder also has the purchase order paperwork and notes I took while talking to the art buyer or art director. All the model vouchers and model releases are stapled together with a reference Polaroid. The folders are numbered consecutively. On big jobs I'll have folders for receipts and paperwork, one for model information (schedules, releases, vouchers), and one for product and shoot information.

I place the manila folders, numbered and in order, in a hanging file for every job I've done. When I have a bunch of paid jobs clogging the active file, I remove them and put them, in order, into a banker's box, which is clearly marked with the job numbers it holds. I know this sounds basic and simplistic, but I can't emphasize enough how important being this organized is.

We keep detailed notes on which models are used in which shots and on which days. This is crucial when you need to know the information a year or two later. Sometimes the client wants to reuse a photo, and the rights granted by the models have expired. It's vital to know not only each model's name, but also which agent or agents were used to book them. What were the terms of the initial booking? Were further rights negotiated at that time? Does the usage still fall under the original terms? Not being able to locate this information can lose you a very lucrative job or reuse fee.

Some of the information that ends up in the banker's boxes is duplicated elsewhere. I will keep, for example, model releases for stock shots in a model release file. Sometimes I need the information to recreate a shoot. I've sent original releases to clients only to have them call me several years later asking for a copy because they lost theirs and the model was pounding at their door. I've saved their bacon by coming up with a copy of the model release and a copy of the original model voucher from the shoot. Keeping all these notes makes my life a lot easier.

THE LAB

I consider a lab part of my equipment, and like everything else, it's got to be reliable. A lab I can trust, one with which I have a good, reliable business relationship, is vital to the success of the entire production.

First and foremost, I need a lab that is consistent from day to day. Even though I run jobs in batches as a fail-safe, I need to know that the film I ran at 10:00 AM will look like the film I'll be

running at 3:00 PM. If the lab screws up, it's my responsibility. No matter what they do, no matter what I tell my client, it will always fall on my shoulders and be my fault. That's part of being a professional. The photographer is the Harry Truman of his (or her) world: The buck stops at the photographer's desk.

The best way to test a lab for consistency is to shoot five or six rolls of film at the same time and then drop them off at the lab at different times over a period of several days. If you're tight on cash, you can tell the lab what you're doing, and since this isn't a job, ask them if they could cut a deal for the six rolls you need to process. The answer the lab gives should tell a lot about the lab. It's a reasonable request in seeking a lab to send your work to, and if they say no, you know they may not be too flexible when crunch time comes. If they're helpful in your test of their consistency, they'll most likely be able and willing to help you with difficult jobs. As far as color control, you'll have to determine that yourself using whatever parameters are most important to you, such as skin tones and neutrals.

Labs drive me crazy when they come up with a bunch of excuses for screw-ups that I know are just excuses. I'd much rather have a lab admit that they screwed up rather than give me excuses and point fingers. A lab that owns up to its mistakes is a lab that's aware that mistakes can be made and can fix them. A lab that says an irregular scratch was caused by my camera is a lab that's blowing smoke and most likely will continue to do so. (How do I know they're not telling me the truth? A camera scratch is usually straight; an irregular scratch most likely comes from the lab.) If the lab doesn't own up to the problem, how can they solve it?

Many times it's just one person at a lab that makes it run well. I worked with one lab that did wonderful work, until all of a sudden their quality control went to hell. Soon thereafter, the lab's former technician showed up at my door to tell me he'd opened his own lab. I switched and was quite happy. Several years later he left the business and, sure enough, the quality at his lab went down, too.

Another consideration is location. With so many labs to choose from in my area, I want to work with one that's located fairly close to my studio for quick turn-around time. Because of the way I split my film runs and run test rolls, using a lab far from my studio can become a major problem. (I now divide my business between two labs, for no particular reason.)

I also make sure that I stay on good terms with whoever is actually processing the film. For instance, the Process E-6 technician at one lab I work with has a baby girl, so whenever I can I send him diapers and toys from our shoots. When I'm in a crunch, he really comes through. He also helps me when I need something special. For my last trip to Europe I needed clear 35mm film cans (because it's easier transporting lots of film through security with the film in clear canisters, which, in turn, are kept in clear plastic bags). He gave me 125 empty canisters that I filled with EKTACHROME E100S—a film that is sold in black canisters. It made going through security a breeze.

The film comes back from the lab, and your model's hair is bright green! Oh wait. The wig is *supposed* to be that color. Lucky for you, because the lab was processing all the film from the shoot in one batch. I actually have had film come back from the lab with a green cast. Granted, it only happened once, but that was one time too many. Because of that incident, I never give the lab all the film from a shoot at one time but rather split it into two batches. When the first batch is in my hands, I send out the second batch from the shoot. Being this careful keeps me from turning green and has protected several jobs over the years.

CHAPTER 6

BUSINESS MATTERS

Of Agents, Art Directors, and Art Buyers

At my studio there are standard lines of communication. My agent handles all the financial communication and negotiations while I handle the creative dialogue with the agency or client. The process begins with the art director, who has a layout and needs a photograph. The art director contacts the art buyer, who is in charge of the financial considerations at the agency, such as whether the agency has the budget to use a particular photographer. (If the agency or client doesn't have an art buyer, the art director or creative director handles most of the art buyer's functions.) The art buyer negotiates the price and the terms for the agency, issues a purchase order for the job, and checks the bills once the job is complete. Sometimes the art buyer also shows the photographer's portfolio to the art director. The art director always has the last say in creative decisions, such as which photographer is capable of doing the job. ■ When the art buyer receives a job that needs an estimate or a bid, he or she contacts my agent, who gets as much information as possible about the job,

Point and shoot. Plug and play.

Electronic Still Image Camera: the faster, easier, more exciting way to shoot and view the pictures of your life.

The fun begins when you pick up the Sony Mavica camera, a slim, pocket-sized wonder that electronically records up to 50 pictures on a Mavipak® 2" video floppy disk. Then enjoy your pictures instantly. To view yourself, your family and friends, just connect the camera to the playback controller to your TV set!

Suddenly, there's more fun for your family. More life for your parties. More adventure for your vacations. It's the Sony Mavica®

About the size of a mounted 35mm slide, the handy, reusable Mavipak 2" video floppy disk holds up to 50 pictures.

Not only will you see bright, beautiful color pictures, you'll see a range of advantages conventional photography simply cannot match. You'll see your Mavica pictures right away. There's no bringing film in for developing. No processing time to wait. Because you view Mavica pictures on a TV set, the whole gang can see each picture at the same time. Forget about finicky slide projectors and cumbersome screens. And there's no need to turn out the lights.

The Mavica Electronic Still Image Camera is the brightest new development photography

has seen in quite some time. And it's brought to you—appropriately enough—by Sony, the innovator in electronic still imaging. Let Sony introduce you to this entirely new mode of photography. One borne of the age of video.

Sometimes you have to shoot images that are later placed within the main ad. These are called inset shots. Though small, these shots can take up as much or more time and energy as the main shot. Just like a chain, an ad is only as strong as its weakest link. A weak image will bring down the whole ad.

asking, for instance, whether the agency wants a bid or an estimate, who the other photographers we are bidding against are, what usage rights are involved, whether the photography will be black-and-white or color, and whether the background will be a set or seamless. It's amazing how many times someone forgets to tell us something basic—like it's a black-and-white photograph. A good agent will anticipate any questions the photographer might have about the layout and understands that information, such as the fact that the photo will be used as a billboard, will affect the choice of film format, which in turn affects the estimate.

After my agent gets this information and a layout, which is usually faxed to me (but you might get it by e-mail), I start on the estimate. I call my various support people—stylist, set builder, prop maker—to see if they are available to work on the project. (Not being able to use my regular freelance staff could influence my estimate.) I run the job past them and get as much information as I can and their prices.

My stylist or set builder may point out something I've overlooked that will affect the price. I'll even hit the *Yellow Pages* to locate a prop or an item that I need for the estimate.

After I get as much information as I can, I contact the art director with any artistic questions or problems I may have encountered in my research. If I have any financial questions, I contact my agent, who in turn contacts the art buyer. When I have a question that only the client can answer, the art buyer or the art director routes the inquiry to the agency's account executive who is handling that account. Sometimes the account executive can answer for the client, sometimes he has to contact the client. Finally, with all my questions and concerns answered, I go over the numbers with my agent. We adjust, write up, and finalize an estimate (or bid), which my agent submits to the art buyer.

If at any time before or during the shoot I am asked to do anything that would incur an expense not included in my estimate or bid, it's my agent's job to contact the art buyer immediately and see if the overage can be approved. For example, the art director may decide at the last minute that he just can't live without a gold-plated kumquat on the set. The art buyer will either say, "Fine, it's OK for the budget," which is usually the case if we're talking about something that's crucial to the job or isn't outrageously priced, or they'll say, "Forget it," at which point I try to figure out how to spray-paint a kumquat.

Art buyers rarely veto additional costs as long as they're told why we are incurring the overage before we incur it. Sometimes the art director will decide the day of the shoot that he needs a small shot of the product; it's what's called an "inset shot" in the ad. If I don't negotiate the fee for this shot before I shoot it, I'll be in a terrible bargaining position later, after I've shot it and it's time to be paid. Generally, an increase of ten percent of the estimate doesn't have to be approved; it's an accepted variance. Still, I consider it good business practice to inform the art buyer of any increase as it happens.

The Estimate

When someone asks me, "What do you charge for a photograph?" I respond by asking, "What does a car cost?" Meaning, are we talking about a new car or a used one, a four- or an eight-cylinder model, a luxury auto or an economy model? And do we want to buy, lease, or rent? Commissioning a photograph is not like ordering a meal in a Chinese restaurant. The client can't say, "I'll have a portrait from Column A and a product shot from Column B, and, oh, yes, I almost forgot, can I see the dessert menu?"

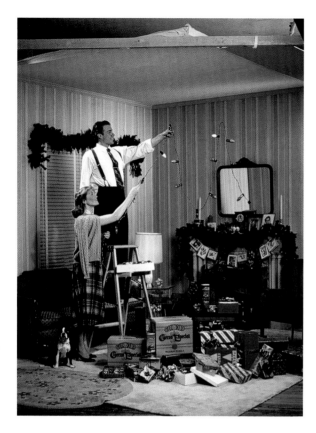

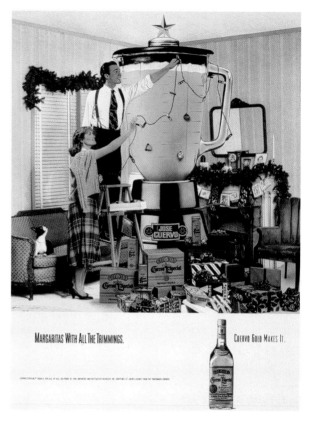

MARGARITAS WITH ALL THE TRIMMINGS. CUERVO GOLD MAKES IT.

In estimating shots, the smallest thing can trip you up. Experience and knowing where to get specialized props help keep the production costs low, but it's always the unexpected that tests your mettle as a photographer. The item that you thought would be a problem, like the late forties couch, turns out to be a breeze. And what you thought would be a breeze, finding a well-trained Boston terrier, turns into a small hurricane. If something unexpected comes up that throws your estimate out of whack, it's important to contact the art buyer or art director to let them know so they can make a decision about how to proceed.

Just as an eight-ounce soft drink can cost 20 cents when bought in a two-liter bottle at the supermarket and six dollars when served at a nightclub, the cost of a photograph can vary widely. And so, like most illustration photographers, I don't have a set price. How much a client pays for a photograph depends on exactly what he or she wants, needs, and is willing to spend. A portrait made for a high school yearbook and a portrait of a CEO of a multinational corporation for its annual report bear the same relationship as a Big Mac at McDonald's and a chopped steak at the Four Seasons. They're both burgers, but overhead, materials, and the end result distinguish them.

So while there is no standard price for an image, there are standard questions that need answering after receiving the layout in order for you to make an intelligent estimate.

First, you must know how the photograph will be used and for how long so usage rights can be negotiated. I never sell a photograph, I

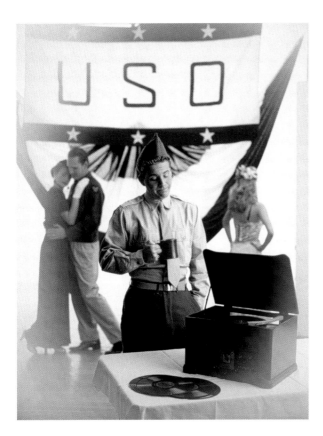

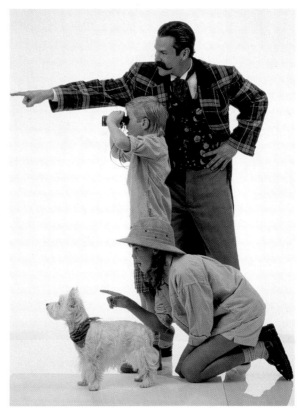

sell its usage rights. If a client wants to buy a photograph outright, to own it and do as he pleases, I'm going to charge a lot more than if he wants to use it for a fixed period of time in a defined market. Is the photograph going to be used for an editorial publication, a consumer ad, a trade ad, a free-standing insert (one of those coupon sections in the Sunday papers or in magazines), a billboard, or a poster? How long does the client want to use it for? A month, a year, two years, forever? Does the client want regional rights for one city or area of the country, or international rights?

Then production values come in. Does the layout need to be followed exactly or is there any flexibility? Will the photo require a complicated set to be built or will we just need a roll of seamless? Are there special effects involved? Are there budgetary restrictions? Is this a prestige product for which they want to spend accordingly? Do they want the best of the best in props?

When producing a studio shot for a client, you have basically two choices in how to set it up— either build a set or shoot against white seamless. Sets can be simple or elaborate and can be customized to the smallest detail to fit your client's needs. If a scene's background is to be added by the designer at a later stage, shooting against white seamless is ideal.

Does the setup have to be done on location or can it be done in the studio? I may think it's easier to go on location locally to get the feel of an All-American house, for example. But perhaps the client has determined the shot must be done in Florida, even though it may be hard to find an All-American house without palm trees. That's the client's prerogative. As I like to say, "It's their nickel."

After I get the information about usage and the lavishness or simplicity of the production, I can work on pricing the photograph. Photographers gain experience at pricing the same way people learn about sex: They talk to their peers, listen to a lot of tall tales, make a bunch of mistakes on their own, and gradually they learn. Some photographers learn faster and better than others; almost all exaggerate the story of their learning.

There are two parts to any estimate: the creative fee and the production expenses. Photographers base their creative fees as much on their experience at pricing photography jobs as on their experience behind the camera. Depending on the photographer and the advertisement involved, the creative fee can range from $500 to $15,000. Art buyers are usually aware of the ballpark into which creative fees should fall. What varies most from estimate to estimate are the production expenses. One photographer might see an ad as a location shot, while another sees it as a studio shot. In these days of tighter and tighter budgets, estimates and their cousin, the bid, become more and more important.

There's an important difference between a bid and an estimate. A bid is always an estimate, but an estimate isn't necessarily a bid. Whenever you provide prices for a client, you are doing an estimate, but if other photographers are also doing estimates for the same job, then your estimate becomes a bid. If you are the only photographer doing an estimate, then it's simply called an estimate.

An estimate shows the art director, art buyer, or client not only how much the job is going to cost, but also how the photographer plans to shoot the project. Are you planning a luxury cruise when they just want a canoe ride? Are you setting up your best Cecil B. De Mille production when they really want a home movie? Or vice versa. I've heard of photographers scaring away art buyers and losing jobs because the buyer knew the photographer wasn't estimating high enough for the level of production the client was expecting. Buyers are well aware of the costs involved in shooting high-end and low-end jobs.

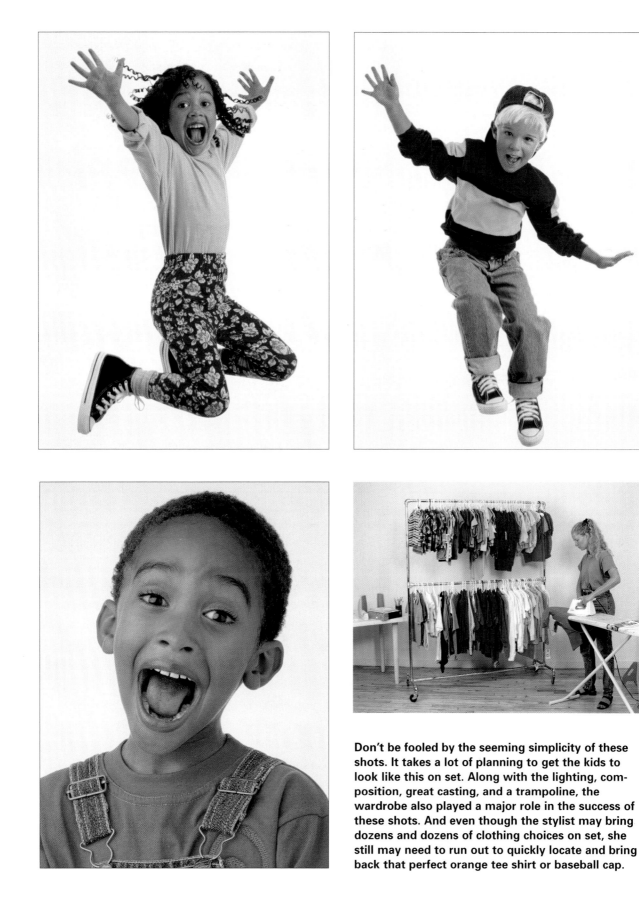

Don't be fooled by the seeming simplicity of these shots. It takes a lot of planning to get the kids to look like this on set. Along with the lighting, composition, great casting, and a trampoline, the wardrobe also played a major role in the success of these shots. And even though the stylist may bring dozens and dozens of clothing choices on set, she still may need to run out to quickly locate and bring back that perfect orange tee shirt or baseball cap.

Let's assume you have two photographers of equal talent bidding on the same job. One hands in an estimate that reads:

Fee:	$3,500
Costs:	$5,000
Total Estimate:	**$8,500**

The second photographer offers an estimate for $9,023.80, with this breakdown:

Fee:	$3,000
Casting:	$750
Film:	
36 rolls of 120 @ $25.50: $918	
8 packs of Polaroid @ $21.35: $170.80	
Casting Film: $300.00	
Total Film:	$1,388.80
Crew:	
Assistants—2 @ $175: $350	
Stylist @ $500/day (one day prep, one day on set): $1,000	
Total Crew:	$1,350
Props: Wing chair, love seat, tables, misc.:	$600
Wardrobe: For two adults and one child:	$500
Messengers:	$200
Set Expendables:	$175
Studio Misc.:	$160
Models:	
2 Adults: $600	
1 Child: $150	
1 Backup child: $150	
Total Models:	$900
Total Estimate:	**$9,023.80**

Now, if you were the art buyer, which photographer would you feel more comfortable with? The $8,500 bidder who submitted three lines, or the $9,023.80 photographer who told you where every nickel would be going? Believe me, most clients want the breakdown. (Of course, they might ask both photographers to come down on their estimates!)

If you look at these examples carefully, the more expensive photographer is actually cheaper. The fee is less, but more money is going into the production of the photo. Clients like that. Ask the client for another $1,000 for the production—let's say for a

great prop—and chances are it'll be OK'd in an instant. But if you ask to boost your fee an additional $300, the reaction is going to be, "Not so fast."

Let's take a moment to talk about terminology. We've already discussed the difference between an estimate and a bid. There are several types of bids. With *competitive* bids, the lowest usually wins the job. With *comparative* bids, the art buyer uses the bids to compare prices. In that case it's more likely that she already has someone in mind for the job, but wants to see how that shooter's estimate compares with those of a few other photographers. If you are not the chosen photographer, you are "rounding out" the bid.

Being the one who's rounding out a bid is a tricky position to be in because you never know for sure that that's what you're doing. Preparing a bid takes a lot of time and research, and if you're merely rounding out, you're doing it for nothing. My agent and I are very good at smelling out bids that I am just rounding out. She will directly ask an art buyer or art director if they already have someone in mind for the job and if I am just rounding out the bid. Usually the buyer is straightforward, and if I am rounding out the bidding, I try not to spend as much time researching my costs as I would if I were the "pick" photographer. I still try to do an intelligent bid. Hey, you never know—something could happen with the "pick" photographer: If his schedule changes or his bid comes in ridiculously high, suddenly I've got the job. But instead of spending half a day or more coming up with a bid, I'll spend about an hour doing a guesstimate. That means that instead of calling hotels to get real prices, I'll go with ballpark prices. I know that if I estimate $125 per room, I've got a pretty safe budget to work from. The important thing to remember with a guesstimate is to be careful what you bid; you may have to live with it.

Some bids are *absolute* bids, such as those I do for government jobs, like a shot for the post office or the army. In these cases, the bids are sealed, and the lowest one, even if it's only by a nickel, gets the job. Every job like this involves at least a three-way bid. There are no estimates. In these cases, it helps to do the research to find out, for example, that a hotel room in the region in which you're going to be shooting costs $99 rather than the $125 you would have guesstimated.

There are also *hard* bids, in which your estimate or bid becomes the budget, and you have to produce the job at or below that price.

And there are *bottom line* bids or estimates, those in which you bid a fixed amount to do the job. If you produce the job under the budget, you keep the difference; if you go over the budget, you eat it. As the saying goes, "Some days you eat the bear, and some days the bear eats you."

The Purchase Order

It's very important to carefully review the agency's purchase order. There may be terms that are objectionable or onerous, and it's up to the photographer to either re-negotiate or amend the purchase order. Anything I write on the purchase order will supersede anything previously written. If the purchase order boilerplate (all the stuff in fine print) says the agency has all rights to my photograph, and I've negotiated trade usage for one year, and it's written on the front of the purchase order that the client is buying trade usage for one year, then all I've given the agency is trade usage for one year. Verbal negotiations or understandings are worthless. Several times I've had art buyers assure me that everything will be all right because they would never do this or that. I always ask, "That's fine, but what if at some point you're no longer with the agency? What then?" I must have the final arrangement in writing on the purchase order, either typed or handwritten by me, my agent, or the art buyer, before I'll sign it.

I also cross out any indemnifying clauses in a purchase order unless I'm selling one of my photos from my stock. (I know the origin of the concepts behind my own stock images.) I will not indemnify a client if I don't know how they came up with the layout (they could have swiped the idea from another photo) or if I don't have any say in the ad's copy or where the ad is being placed. They could change the copy or run it somewhere inappropriate. While I can sue for the misuse of my photo, I don't want a piece of paper saying I'm indemnifying the agency from any lawsuit when a model comes around to sue.

If the layout was copied from an existing photograph without my knowledge, the original photographer can sue (as I would), and with an indemnity clause on the purchase order, I could be the one left holding the bag.

If I see an indemnity clause, out it goes. I've had to explain this several times to agency lawyers, and I have never had one of them pursue it after I asked, "Would you sign it in my position?" If they can get you to sign it, they've covered their behind; if not, they are no worse off.

Your motto as a photographer should always be "Show Me the Paperwork." If there is an indemnity clause in their paperwork and they tell you it's unnecessary or just a technicality, don't believe them! Have them fix the paperwork, and sign only what you must. Don't let the wording come back to haunt you.

Putting your paperwork in order can save you loads of frustration. It's very important that all the terms be written down and spelled out. Be careful not to relax your procedures or rely on friendship and good will, even with long term clients. That only works until the company has been sold to Attila the Hun, Inc., or your friend gets fired and replaced by Attila himself.

Rights and Work for Hire

When I provide the client with an estimate, I spell out all rights being granted. When the client issues me a purchase order, I check the wording on both the front and back. Any terms written on the front of the purchase order (by either me or the client) supersede anything that's preprinted on the back.

It's important to understand the difference between selling "all rights" and doing a "work for hire." If I sign a work-for-hire agreement, I'm surrendering my rights, including the copyright, to the photograph. If I want to use that photo in my portfolio or in a promotional piece—or even in this book—I can't use it without the copyright owner's permission. The photo is no longer my property.

On the other hand, if I sell only "all rights" to the client without it being a "work for hire," I can still retain copyright, and thus ownership of the photograph. I can also put limitations on an all rights deal, making it a "limited rights" deal. With these I can limit the usage, for instance selling rights only for trade magazines,

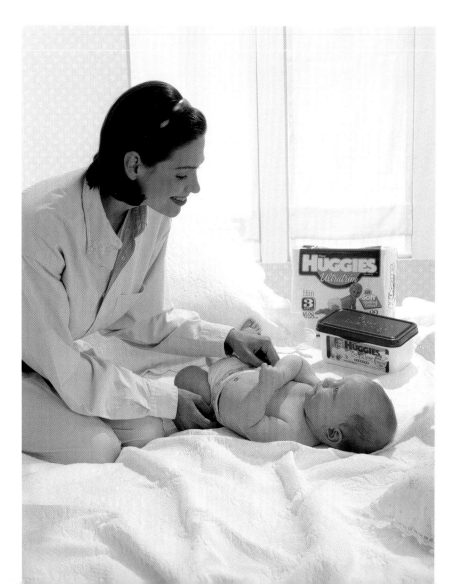

While some photos clearly have no potential for resale, it's still very important to maintain the rights to your work. A photo of a baby with a product box has very little reuse value, so I will be very flexible on selling the client additional rights. However a close-up of a baby's face with no product in the frame can potentially be used to market a multitude of things. In either case, I never sign away my rights to any photo.

direct mail, or editorial use. I can also limit the length of time they can use it—six months, one year, two years, or even three years. After that period, all the rights to the photo revert to me. Usually I sell limited rights, but if the client wants all rights, I sell them to him and charge accordingly. For some images, such as a client's product on seamless, I can be very reasonable. If it's a more universal shot with a longer potential life, such as a baby on seamless, I charge quite a bit more. The rights to those types of specialty shots can run into the high four or low five figures.

This is an important distinction to make: You are selling *the rights to reproduce* your photographs, not the photographs themselves. When the job is done, I issue my invoice, again stating the terms of what I am selling (e.g., "a color photo of a lizard for one-year usage in consumer magazines")—and I sign my invoices. It's important that the entire paper trail—my estimate, the client's purchase order, and my invoice—all have the same terms regarding the period of use and for which media the usage is licensed. You should also state if there is any usage you are not allowing, such as billboards or television. Be as clear as you can possibly be. You can cross off and write in any terms you want on the purchase order. The client's PO is only an offering, just as your estimate is. Do not hesitate to make changes or clarify the terms.

Don't let the legal double talk fool you. Either learn how to read it, ask for clarification, or find a lawyer who will help you go through it. There are pro bono lawyers, such as the Lawyers for the Arts in New York, that help photographers and artists free of charge or for a small fee. Contact your local bar association, law school, or friends of friends that are lawyers. Do anything to make sure you're not giving away your life's work.

I once sold national consumer rights to one of my stock images. After a year the rights expired. Then the client ran the ad again in *People* magazine. We called the agency. They no longer had the account. We called the client and started to get the runaround. I then sent an invoice for one and one-half times the amount they originally paid. I added a note saying that if we did not receive payment in ten days, the invoice was void and my lawyer (whose name, address, and phone number I thoughtfully provided) would be handling the matter. I got a call a week later from the president of the company. I explained that this was a very reasonable settlement for a violation of my copyright. I had all my paperwork in order; it was quite clear. I said that if my lawyer took the case, I would ask for and most likely get a lot more money; it would just

Now here's an example of a photo that has a lot of potential resale value. When negotiating for a photo like this, be aware that if you are not specific in the rights you are granting, it could be used by the client in many different ways. When negotiating rights, try to be fair by giving your clients the rights they need at a price that's reasonable for both you and them. A good deal is one in which both parties feel as if they've won.

take me a lot longer. The company president wanted to know why I was charging more than he paid for the original rights. I explained that otherwise there would be no incentive for him to contact me. He then said that he bought a lot of photography, and if I gave him a break on this, we would work together in the future. (If anyone believes that, I have a nice bridge in Brooklyn I'm offering for sale.) I answered that tired negotiating ploy with a tired negotiating ploy of my own: "Pay me this amount now, and I'll gladly give you a big discount on future work." He paid the invoice, sent the film separations of my image, which I had demanded, and I never heard from the company again. What a surprise. But I'm still here, still in business without him. Clients like that will drive you out of business rather quickly if you let them get away with these things. Never sell yourself or your photographs short.

The bottom line is that, as the photographer, you are responsible for making sure that all the paperwork (both yours and the client's) is clear regarding the rights you are selling. If you are vague, someone will take advantage of you at some point. There is a world of difference between stating: "For public relations usage" (with no time limit) and "For public relations usage for 3 years; not including magazine covers, advertising, or TV."

Rights and copyrights can be very complicated. In fact, many lawyers are unfamiliar with copyright and intellectual property laws and their implications for photographers. I've heard of one photographer who sued a client for using a photograph on a package without his permission. His lawyer sued for the photographer's regular photo fee in what amounted to a theft-of-service suit. What the lawyer should have sued for was copyright infringement, and he should have pursued it as a federal case. This would have entitled the photographer to much greater damages for the unauthorized use of his photograph. And if the photographer's paperwork is in order, most of these cases are settled out of court. Copyright violations rarely occur with large advertising agencies because their paperwork generally covers everything they need, and they are usually very sophisticated about copyright laws. If you find yourself in this type of situation, make sure you get a lawyer who has handled copyright and intellectual property cases.

This area of photography deserves its own book. The war stories alone would be worth the price. I recommend that photographers who need more information on the subject contact a photographers' trade organization. Better yet, join one of them. It's probably the best single thing you can do for your business.

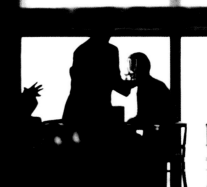

CHAPTER 7

THIS GUN'S FOR HIRE

If you take a photo of a tree falling in the forest and no one sees the photo, does the photo still exist? Not if you're a commercial photographer. ▪ Frankly, my goal is to have as many people see my work as possible. I want art directors to flood me with assignments that inspire and challenge. Okay, I believe in fairy tales. So what do I really do to get assignments? I've often said, people do not beat a path to the door of the guy who can build a better mousetrap; rather, they beat the path to the door of the person who promotes a better mousetrap. People will not buy mousetraps or photographs unless they are aware and informed—and that means advertising. Advertising yourself is called promotion. Simply put, you have to promote yourself and your talents in order to get assignments. ▪ One thing every photographer wants to know from every other photographer is this: How do they get work? If they don't say it out loud, they're thinking it. ▪ What can you do to get the assignment you know is perfect for you, the one you're dying to shoot? Promotion. Promotion can position you in your market so you can get those choice assignments.

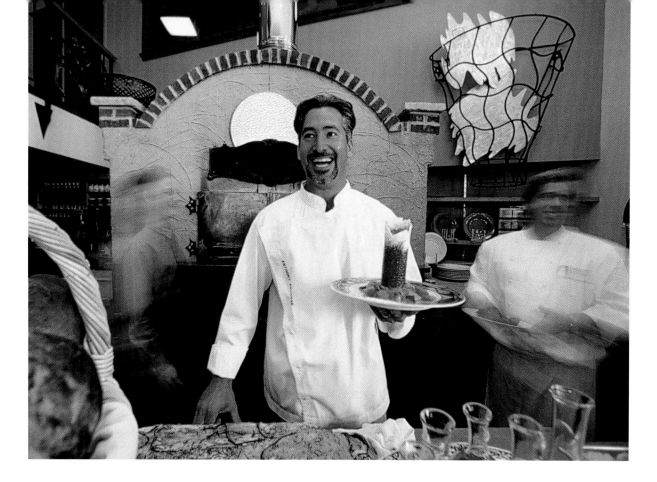

I got a call from American Airlines to shoot for an article on Boston restaurants that would be going in their in-flight magazine. What great timing. It was a plum assignment after a full summer of art directors looking over my shoulder. I was given three days in Boston to shoot whatever I thought was interesting. This was the last shot of the trip. Travel, great food, and a paycheck—that's the life. But it took years of sweat and experience to get a call like that.

To me, promotion is just as important as camera equipment— maybe even more important. After all, I can always rent a camera or a lens for an assignment, but with no assignment, there's no reason for the camera. And I can't rent assignments.

Some photographers believe that if they keep their prices low, clients will come to them with plum jobs. Rarely. When a potential client has a big-budget assignment, he wants a big-name photographer—or at least his perception of a big name. If my prices are low, I can't possibly be as good as the high-priced big name up the street. And in many cases the big name got a big name as a result of good promotion. Good promotion leads to good assignments that result in great photos that photographers use in great promotions. And so the beat goes on.

Promote Your Strengths

As photographers, we are in the communication business, trying to get a message across in our photographs. We need to also communicate our talents to the marketplace. And the first step in doing that is to decide where your talents lie. Just what is it you're selling? Are you a product photographer, a people photographer, an underwater photographer? And if you shoot products, what kinds are your forte—hard goods, soft goods, food? If you shoot people, do you work well with kids but better with businesspeople? Do you have a great eye for fashion?

The biggest mistake I see many photographers make in their promotion is to advertise themselves as "everything" photographers and not play to a single strength. Their promotions show a little of this, a little of that, and one shot that's something they happen to like a lot. It sends a confusing message. Cramming too much information into one promotion gives potential clients no clear idea of who you are and what you're good at.

I need to be as clear in my promotions as I am in my photography. I carefully pick images that send a distinct message to the people I want to work for. Of course, the message conveys the type of work I want to do. I don't send images I think art directors want to see because what I think they want is never what they really want to see at all! But if I send images that appeal to me, I end up hearing from art directors who like what I like. Conversely, if I send images

A twinkle in the eyes, a heated argument, a shared secret. I try to capture expressions that are universal, representing moments that are true to the human experience. I've found that images such as these are what I do best, so they are what I promote.

that I'm not in love with, I end up with projects that I'm not in love with. So I always try to show the work of the photographer I want to be. I'm not trying to get work from every art director out there. A small number of art directors can give me the assignments that appeal to me, artistically and financially. They are the ones I promote to rather than the entire population of art directors.

OK, let's say you've worked out your strengths, picked the photos you'll use in your promotions, and the photos that will back them up in your portfolio. Now what? One of the first elements in a good promotional campaign is simply your name. You need to make it clear and easy to read on your promotions. A memorable logo is great, but a good typeface is really all you need. Both would be ideal. (I have only one comment about typefaces: I've seen ads for photographers that have their name in such a fancy or cute typeface that it takes a minute to understand what it says.)

I suggest having a designer help you. Just as you want people to hire a professional photographer to take photographs, you really need a professional designer to design your promotions. My logo is my last name spelled phonetically, and it's proven to be a very important asset. The tag line that usually appears with the logo—"Just call me Jack"—appeals to and reflects my sense of humor. It humanizes my ads and helps reinforce the idea that I'm a friendly guy who is good with people. Plus, I have a lot of images that back up the image my logo conveys.

I've been very fortunate to have developed a good name and reputation in this industry, but I've learned that there are always art directors who have never heard of even the biggest names. So, if you're designing a single-image direct mail promotional card, make it clear that you're a photographer selling your photographs and not a model, stylist, hair and makeup person, or graphic designer. Though, come to think of it, it wouldn't be bad if the recipients thought I was this sumo wrestler; at least I'd have an upper hand when it came to negotiating.

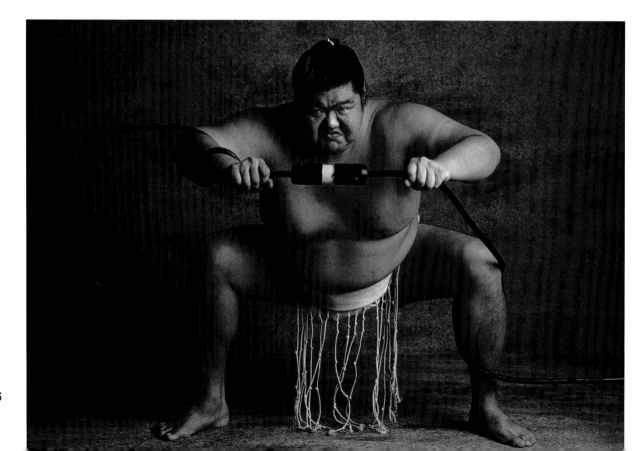

An art director at a large advertising agency who couldn't remember my name did remember the logo. He went to the art buyer at his agency and asked to see the portfolio of "the photographer who spells his name like a dictionary." Marty Goldstein, who used to own *The Creative Black Book*, conceived and designed my original logo. I've had the typeface updated several times over the years by various designers, but the idea has remained consistent.

Another thing to consider: Is it clear from your promotional pieces that you're a photographer? Don't laugh. Art directors are constantly bombarded with promotions from photographers, illustrators, stylists, and hair and makeup people. Can they quickly tell you're a photographer and not a makeup artist? The message: Always include the term photographer or photography on your promotions. Remember, no matter how big your name and reputation get, there are always new people in the industry who have never heard of you, and it's surprising how many of these new art directors are in charge of very big assignments.

The Cumulative Effect

So, now you have your logo and your images. What vehicle do you want to use to send your message? Direct mail? Promotional source books, such as *The Black Book, The Workbook,* or *Klik*? An ad in an art director's magazine, such as *Art Direction*? Or an ad in a visual image magazine, like *Archive* or *Graphis*? The truth is, all of the above work, but usually not instantly. Too many photographers look for that magic bullet promotion, the one that will open the door to all sorts of assignments. It doesn't often work that way. Some of the better assignments I've received were the result of doing a lot of promotion over a period of time.

Photographers often ask me how well a particular mailing or promotion worked. That's a hard question. I believe everything works in combination with something else. Although it does happen, it's rare for an art director to give a photographer an assignment the first time they see a photographer's work. Usually they want to see a range of work in the form of direct mail pieces, book ads, and a portfolio viewing. After a while they feel they understand the photographer's style and what the photographer is capable of. There have been times when an art director will call with an assignment because they loved a certain photo I mailed out—but it may be a card I mailed years ago.

Remember that the most successful mailer merely gives you the opportunity to show off your most important promotional tool: your portfolio. A lot of times you'll get calls when you send out a killer promotion, but the calls will always be to see your portfolio, not to

give you an assignment. A good friend of mine is a top name in the industry, with tons of magazine covers of everyone from United States presidents to film stars. He mailed out a promotional piece one year that was an accordion fold-out card with some 20 images. He produced three of these promos, each with a different theme: magazine covers, ads, and portraits. After sending out these 60 images, the calls he got were always to see his portfolio. What the art directors didn't understand was that those pieces were his portfolio!

Entice Your Market

Promotional images should entice art directors to want to see more work. In essence, the portfolio backs up the work that the photographer is promoting. I wouldn't use a great people shot in my ad if I were looking for still-life assignments. Sounds simple enough, but you'd be surprised how many people will show any great image they have, say a computer-manipulated graphic—and then have few, if any, other pieces to support it.

When I was first starting out, some of my better promotions were novelty promotions: home-baked cookies in a tin with my name on it, an oversized Kodak slide mount with a mirror where the film would normally go and my logo stamped on the side, T-shirts, jack-in-the-boxes, whatever. This didn't necessarily get me assignments, but it did get my name noticed and set the tone for the type of humorous work I was doing at the time. Before I did these promotions, buyers said, "Jack what?" and blew off my rep.

I wish I could give you a formula for picking photos for promotions. The bottom line is to try to project a consistent message. If you present too many images that don't relate in either content or style, then you're sending out a blurred message, which confuses your potential clientele. The best advice I can give you in coming up with an effective promo is to hire a good, professional designer. As in photography, you usually get what you pay for.

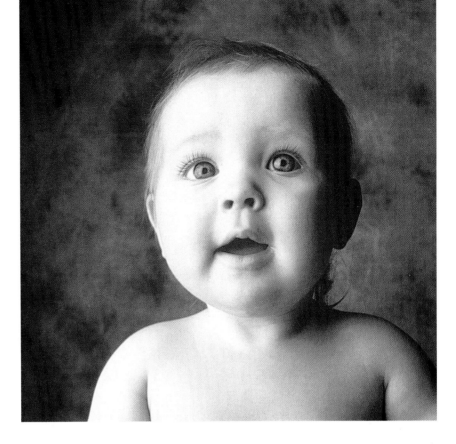

I JUST WANT TO BE A KID.

In promotions, as you sow so shall you reap. If you want to photograph children, show shots of children. If you want to photograph young active couples, show young active couples. If you want to shoot locations, showing portraits won't get you on the plane. As a rule, the bait you cast out determines the assignments you'll pull in. The trick is to constantly send out good images of things that you would like to shoot.

After the promos they said, "Oh yeah, the guy with the dictionary name who sent out the mirrors. Sure, come on up, I'd like to see his book."

A Midwestern photographer I know unintentionally changed his whole career with promotions. He was having the familiar experience of local art directors getting a bigger budget for their jobs and hiring a "better" (read: big-name) photographer. So he began advertising in national promotional source books, like *The Black Book*, in order to reach art directors in his own hometown. He thought it would add to his stature locally. He figured national promotion would change the local art directors' perception of him. Think nationally, work locally. Well, his ads worked all right—they got him recognized locally and nationally. He ended up with more national, high-paying accounts than local ones. Today a lot of local art directors can't afford him. The moral of the story? The same as most of these stories: It always pays to promote.

Brave New World

As I write, there are changes happening in the world of portfolio presentations. For years photographers' portfolios were shown in richly made leather boxes that resembled attaché cases; they were loaded with 30 mil laminations of C-prints and tear sheets. Today, that look is old news, and photographers are finding quicker, better ways to get their images and messages to the market. Laser prints are one way. Digital prints made in the photographers' own studios are another.

Jack Reznicki Studio 212•925.0771 ~ Agent Elyse Weissberg 212•227.7272

Jack Reznicki Studio 212•925.0771 ~ Agent Elyse Weissberg 212•227.7272

Jack Reznicki Stu

I'm now scanning chromes, printing inkjet prints, and placing those images in my portfolio within a day of shooting the image. This keeps my portfolio current, up to the minute. Art directors are no longer impressed by great quality C-prints; they want to see what you can do photographically. They want to see how you see things, how you think.

The speed at which photographers can print their own portfolio and the control they have with software programs like Photoshop or Live Picture is changing the way shooters create and show images. I'm now wondering what to do with my darkroom. It's becoming a quaint, old-fashioned, rarely visited place, as processing and printing are now done more for the love of photography than for any practical purpose. The benefit of the trade-off—from working in a dark, damp, chemical-filled little room to sitting in an ergonomically correct chair and staring at a cathode ray tube screen for hours—is that the computer gives us 100 times the control over our photography. I don't mean getting pigs to fly and clocks to melt; rather it's just control of the basics, like color correction and simple retouching. What once took a lot of money and time can now be done in minutes on the computer. I have a photographer friend who has just started working with Photoshop, and he is totally hooked. After 40 years in the business, he says he's fallen in love with photography all over again. Seeing what he can do with his images on the computer, he's once again experiencing the excitement he had when he was a budding photographer looking at images come up in the developer tray.

Agent Elyse Weissberg 212•227.7272

Jack Reznicki Studio 212•925.0771 ~ Agent Elyse Weissberg 212•227.7272

Jack Reznicki Studio 212•925.0771 ~ Agent Elyse Weissberg 212•227.7272

I understand completely. By the time an image got into my old portfolio book, it was hardly new to me. Now, with a portfolio of new images that are really new—they were shot maybe a week ago—the thrill is back.

I believe we're entering a new era for the industry as we explore new ways to capture images and new ways to show and distribute them. I deliberately use the term "image" rather than "photograph" because digital photography is forcing us to see photography in new ways. In the end though, we're still photographers—or image-makers, or whatever term is currently being used. A rose by any other name remains.

A lot of photographers are scared by all these changes, but many of us see it as just a continuation of the process. We've seen many technological changes in photography over the years—from wet plates to roll film, 35mm, and color, from tungsten to strobes. Photographers with new tools remain photographers.

Ultimately, not even the tools matter. No one who buys my pho- tographs is going to buy them because of my tools. What has always made the difference and, I believe, always will, is how I see and think. As I said at the beginning, I need to be the photographer people hire because of the way I think, not because I'm just a guy with a camera.

CHAPTER 8

PERSONAL WORK

The photo work I do when I'm not being paid to do photo work is very important to me as a photographer. After years of shooting assignments, it could be very easy for me to lose sight of why I started taking photographs in the first place. The love and magic of photography can become just another day job. I believe that in order to keep growing and remain excited about my chosen craft, I have to photograph just for the joy of it. ■ To me, nothing's finer than taking a trip somewhere with 30 pounds of cameras and 15 pounds of film. No assignment, no preconceived ideas, going on a busman's holiday, shooting what I see as I see it. I try to do that at least twice a year. They aren't vacations exactly, they're trips. A vacation is a week or two on a beach; a trip is something that I do to see, to learn, to experience. I love traveling both here and abroad, seeing cultures and places very different from what I usually see. I find travel visually stimulating. One of the reasons I like to give lectures—other than the fact that I like to talk—is that I love to be in new places and experience new things. It can be eating dry ribs in

Memphis or an ice cream cone in Moscow, or taking a ride down U.S. 1 in California or a day trip in the Pays Basque region of France.

Someone once asked me, after seeing me lug my cameras around, if I wouldn't have a better time on these trips if I didn't take a camera along. Not at all. Taking photos is what I do and what I'm about. If I didn't have a camera on those trips, I wouldn't be enjoying them. Looking at some of the photos I've taken on the trips, I get a personal satisfaction that harks back to the days of being a teenager and looking at negatives in the darkroom. The images just touch me.

Ultimately, the photos go to my stock agent, and I make just enough to pay for the trips. It's one of professional photography's best perks—being able to take a trip and call it work. And the thrill of receiving a $50 check for a photo I took of a flat being changed on my rental car in England brings more of a smile than the $3,000 check I bank for doing an assignment. The larger check pays for a lot of the overhead, but the self-satisfaction isn't as great.

I also shoot for myself in the studio when I have the time. Most of my favorite portfolio pieces were done as personal assignments.

So what's the point? Just this: As an athlete practices and a musician practices, so a photographer needs to practice. I need to exercise my shooting muscles, to keep my ear and mind open to new riffs. I don't just shoot when I get a job—that's the road to boredom and mediocrity. Shooting for myself is vital to maintaining quality in my work and keeping my visual muscles in shape.

After many years of just showing commercial work, I'm now featuring some personal work in my ads, and as a result I've gotten some very good commercial assignments from clients who want very controlled advertising work done in my personal style. The first call of that kind that I got was from an art director who loved my personal style and thought it was perfect for his concept. His only concern was whether I would be able to shoot in a studio against seamless! The funny thing is that I'm getting more and more calls for my looser personal style of photography than my commercial style, yet the jobs resulting from those calls are advertising-style jobs. If I promoted just my advertising work, I wouldn't have gotten some of those advertising jobs.